THE **FATE**
OF THE **ANIMALS**

Three Paintings Trilogy: Volume 2

THE **FATE**
OF THE **ANIMALS**

On Horses, the Apocalypse, and Painting as Prophecy

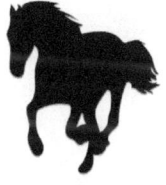

MORGAN MEIS

SL/.NT
BOOKS

THE FATE OF THE ANIMALS
On Horses, the Apocalypse, and Painting as Prophecy

Three Paintings Trilogy: Volume 2

Copyright © 2022 Morgan Meis. All rights reserved. Except for brief quotations in critical publications or reviews, no part of this book may be reproduced in any manner without prior written permission from the publisher. Write: Permissions, Slant Books, P.O. Box 60295, Seattle, WA 98160.

Slant Books
P.O. Box 60295
Seattle, WA 98160

www.slantbooks.com

HARDCOVER ISBN: 978-1-63982-121-1
PAPERBACK ISBN: 978-1-63982-120-4
EBOOK ISBN: 978-1-63982-122-8

Cataloguing-in-Publication data:

Names: Meis, Morgan.

Title: The fate of the animals: on horses, the apocalypse, and painting as prophecy / Morgan Meis.

Description: Seattle, WA: Slant Books, 2022

Identifiers: ISBN 978-1-63982-121-1 (hardcover) | ISBN 978-1-63982-120-4 (paperback) | ISBN 978-1-63982-122-8 (ebook)

Subjects: LCSH: Marc, Franz, 1880–1916 | Blaue Reiter (Group of artists) | World War, 1914–1918—Art and the war. | Marc, Franz, 1880–1916—Correspondence.

Classification: ND588.F384 M453 2022 (paperback) | ND588.F384 (ebook)

Contents

Preface • xi

1. The discovery of a book of letters written by a soldier and artist to his wife during World War I, and the recognition that this book of letters drives us into a consideration of The Great War, which was a kind of Apocalypse. • 1

2. The horror and grief of World War I bring us closer and closer to a specific painting, a painting made by Franz Marc just before the outbreak of the war, a painting that we're desperate to understand but don't yet know how to. • 10

3. We learn that Franz Marc, the soldier and painter, was also a lover of happy, joyful cows and that, additionally, he was not a pacifist. We learn, in short, that happy cows and war all fit together somehow in the mind of Franz Marc. • 16

4. We delve deeper into Franz Marc and his gratitude for war and also explore his desire to paint even though, for most of his life, Franz Marc was a shitty painter. • 22

5. A painter discovers color, really discovers it, really embraces the power and mystery of color, and also, perhaps by extension, discovers the power of fate, of destiny, which is a dangerous power indeed. Heidegger, the Nazi philosopher, makes a brief appearance. • 28

6. More is learned about Franz Marc's love of war and color. It's a bit redundant but necessary to my style of writing, which is prolix and doubles back on itself to a fault. • 34

7. What is an *annus mirabilis*? (Hint: It is not about having a nice time; it is about suffering. Marc suffers and then surrenders to his fate. And then the Spirit comes to him in the form of a horse.) • 40

8. We encounter in Philadelphia a strange man in a bookstore who is probably an angel (or demon) and who introduces to us a book. That book brings D.H. Lawrence into the picture, and that's a problem. • 45

9. We're in the midst of a battle now, between D.H. Lawrence and Franz Marc, around the question of what it means truly to be alive. Who will win? It comes down, as it so often does when you get into it with Lawrence, to the question of fucking and how to do it right. • 52

10. More on fucking (I don't seem to be able to let it go) and then on to pissing (the vulgarities multiply) and then finally on to Jesus Christ. • 57

11. In which we contrast painting that tries to copy how things look, and is therefore mostly silly, and painting that tries to reveal an inner truth about how things really are, which is getting somewhere. • 64

12. We bring up Edgar Degas, for a reason that probably has to do with horses. • 75

13. We continue burrowing into the horse paintings of Degas, his love of bourgeois civilization, and his deep feeling for the absurdity and necessity of that civilization. • 83

14. We finally let Edgar Degas go, his confrontation with human civilization having exhausted us, and we turn back to Franz Marc, who developed a form of painting that takes over from the exhaustion of Edgar Degas. • 95

15. What, exactly, is a prophet? What does it really mean to exist in a prophetic mode, to bring prophecy, to see the future, or the past, or the present? What is a prophetic painting? • 101

16. A prophetic painting is an apocalypse. A revelation. • 110

17. In which we explore some of the other names, the hidden names, of the painting *The Fate of the Animals*, and in which Paul Klee, the great and beloved foil to Franz Marc, enters the picture, figuratively and literally. • 118

18. The drama of Paul Klee and *The Fate of the Animals* becomes even deeper and more surprising, and we begin to realize that the painting *The Fate of the Animals* is itself an object of fate, with perhaps also a little dash of grace. • 125

19. We discuss the third title of *The Fate of the Animals*, which is the most secret title of all, and which brings us to the heart of the matter, perhaps the heart of everything, if we can be a little portentous about the matter. • 133

20. If *The Fate of the Animals* is a revelation, what does it reveal? Can this revelation be spoken? Should it be spoken? • 143

21. Really to look at *The Fate of the Animals* would be to have your life changed, to have everything changed. • 151

22. Franz and Maria Marc dream of building a garden. • 155

23. *The Fate of the Animals* has one last trick up its sleeve. • 158

24. The mad ravings of Odin meet the earth shaking of the God of the tetragrammaton. • 169

25. The last drawings. A surprising vision. The end. • 172

Further Reading • 181

Preface

IN 2011, I WENT TO SEE A SHOW AT THE Museum of Modern Art in New York City. The show was called *German Expressionism: The Graphic Impulse*. I don't remember that much about the show. I do remember a painting by Franz Marc called *The World Cow*, which was painted in 1913.

Maybe it's because I was having some experiences with animals at the time, but the painting had an impact. I think it was the eyes, mostly. The eyes of that cow. Have you ever looked into the eyes of a living cow? It is an uncanny experience, I can tell you. Cows are supposed to be so dumb. Perhaps they are. It doesn't matter anyway. This is not a question of intelligence as such. What happened to me, looking into the eyes of a cow out in a field somewhere in upstate New York, what happened to me was that something stared back. The thing that stared back stared with the calm intensity of a rebuke. Not that there was anger in the cow. There was not. The cow just looked at me. The rebuke was something I created, that I was feeling. My own intelligence felt puny and irrelevant in the face of

the mute and unblinking stare of the cow. Eventually I looked away.

Then, some weeks or months later, I came across the cow in Franz Marc's picture. The cow is red. She sits huge in the center of the painting, with its blend of landscape and abstraction that was Marc's style at the time, just before the outbreak of World War I. Dang if I didn't recognize those eyes, or, to be more precise, that eye. The core of the picture is the left eye of the red cow, swirling there in its infinite and patient gazing.

I'd never really been interested in Marc until I saw that painting. A year or so later, the timing here is surely imprecise, I came across a book of Marc's letters to his wife Maria, written during his time spent as a soldier in the Great War. The letters were so intense I could barely read them. This guy, I thought. He was alive. He'd been beautifully alive. And here he was, still alive in these letters, still so alive on some of the powerful canvases he painted in the years just before the outbreak of World War I.

Some time after this I went to see one of Marc's paintings in Basel, Switzerland. The painting is called *The Fate of the Animals* (1913). I drove to Basel with my dear friend Abbas Raza, who was living in his mountain redoubt in Brixen, Italy. We passed through a vicious snowstorm on the way. I'll never forget that short trip, or the feeling of standing before that giant painting in the museum. This book is the result of those experiences and the thoughts that finally worked their way out from them. It is the second book of what I call

Preface

my *Three Paintings Trilogy* and continues some themes and ideas from the first book, *The Drunken Silenus*. This book can, however, be read independently. I dedicate it to my aforementioned friend, S. Abbas Raza, and to the friend I never had the chance to meet, Franz Marc.

1. The discovery of a book of letters written by a soldier and artist to his wife during World War I, and the recognition that this book of letters drives us into a consideration of The Great War, which was a kind of Apocalypse.

I BOUGHT A BOOK A FEW YEARS AGO. I don't remember why, certainly not for the cover or book design, which is why I often buy books. Sometimes a book just looks interesting, and then I want it because the look calls out to me. Often, the books that force me to buy them were designed in the late 1960s or early 70s. Other times, a book is so badly designed that this, in itself, intrigues. That was the case with this book.

The book I bought is an English translation of letters written by the painter Franz Marc to his wife Maria. It is a thin, hardcover volume published by Peter Lang as part of the American University Studies series. The edition of the book that I've got has about six different fonts on the front cover. Some words are in italics and some words are not. The sizes of the fonts

vary considerably as well. It's as if a small child got into the final layout for the book just before it went to press and started changing things according to a game she was playing in her own head.

The letters published in the book were originally written between September 1914 and March 1916. The letters ceased abruptly on March 4, 1916. This was the day Franz Marc was hit in the head by a shell fragment at the Battle of Verdun. Marc survived the initial impact but didn't live for much longer. He was thirty-six years old.

After Marc's death, Maria Marc made a selection of his letters available to the publishing house Paul Cassirer in Berlin. This was in 1920. The volume was entitled *Briefe, Aufzeichnungen, Aphorismen* (*Letters, Notes, and Aphorisms*). This is the route by which personal letters, handwritten by a German soldier who died in the Battle of Verdun, made their way into general English-language publication. The preface to the original R. Piper edition of Marc's letters opened with the following sentence: "Franz Marc's *Letters from the War* belong to the treasures of twentieth-century German literature." I didn't know that when I first bought the book. I didn't know that it was a treasure. Or maybe I did. Maybe I did somehow know that this was a treasure. I knew and didn't know that I was holding a treasure.

Marc's very first letter, written almost two years before he was to die at the Battle of Verdun, is dated "September 1 (1914), Autumn!" The first sentence reads, "Today I stood guard for the first time, with eighteen

men; it was very moving, a wonderful autumn night full of stars." The last letter, written on the day of his death and during the Battle of Verdun, begins, "Dearest, Imagine, today I received a little letter from the people where I was quartered in Maxstadt (Lothringia), which contained your birthday letter." Near the end of his final letter, Marc wrote, "Don't worry, I will come through, and I'm also fine as far as my health goes." Several hours later he was dead.

The Battle of Verdun (though there were many extraordinarily surprising and terrible battles of World War I) is unique. People still study the battle in detail. They track the various troop movements and the intricate military details. They know the names of all the generals and lower-level military people involved. This requires a certain kind of patience, a certain kind of mindset. The word "clinical" is appropriate here, in both its positive and negative connotations. The clinical mindset is one I do not, myself, possess. I am to "clinical" as "professional wrestler" is to "brain surgeon."

In fact, I suspect that the people who are obsessed with the details of the Battle of Verdun are trying to control something with their supposedly dispassionate attitude to the whole affair. Something about the battle is intolerable to them, to something within them. Some feeling, some root despair or fear is being touched on by the facts of the battle, its reality, its actual happening in the world. To study the battle is to encroach upon that fear and surround it, as it were, with the various analytical tools at one's disposal.

The Fate of the Animals

Or is there also desire? Is it a mix of fear and desire? The person who studies the Battle of Verdun in a clinical manner has no idea what to do with this potent mix of fear and desire, and therefore these persons become studiers, even though probably what they really want, deep down, is to be in the battle, to be in the actual battle and to kill in the battle and to die in the battle, though, in some other sense, this is the last thing they want. They want and do not want. They take some pleasure in the distanced ability to study the battle and to participate in it that way, and this distance is also, at the same time, a kind of torture.

I don't have the desire to understand and to encroach upon the battle in that way. But I often find myself thinking about the Battle of Verdun. My pulse quickens when the battle comes up in conversation, or on the radio, or in books. I remember, many years ago, watching a television documentary about World War I and about the Battle of Verdun in particular. The narrator uttered the following line: "It was one of the most brutal, most sinister battles in military history." As I recall, the narrator spoke with a British accent. He placed special emphasis on the words "brutal" and "sinister." I don't think I'd ever heard a battle referred to as "sinister" in a documentary before. Brutal, yes. But war is always brutal. So, it is surprising when the narrator of this particular documentary does not stop at the word "brutal." His voice continues on, rising in pitch and volume. When he utters the word "sinister,"

he is practically spitting. It's not the typical language and diction of a television documentary.

There is a scene in Stanley Kubrick's *Paths of Glory*. Colonel Dax (Kirk Douglas) is walking through the trenches. The camera follows his movement in a tracking shot—or perhaps we should call it a double tracking shot. We see men lined up in the trenches as Dax walks along. We are seeing the scene from his perspective. Soldiers move out of the colonel's way as he passes through. Then the camera cuts to a backward-moving tracking shot. We are seeing the same scene from the perspective of the soldiers who are watching Dax. Shells begin to explode to the left and right of the trench. We see Dax check his watch. He stops at an observation post. The exploding of shells intensifies. Dax unholsters his pistol and puts a whistle to his mouth. He jumps out of the trench and blows the whistle. The camera pulls back. Hundreds of men leap from the trenches and advance along blasted ground as the shells continue to fall. Colonel Dax continues to wave the men forward, through tangles of barbed wire, muddy pits, the wreckage of destroyed houses, and pulverized bodies.

There it is in a roughly five-minute scene: the true horror of trench warfare. But there's more than horror. What is it that adds an element of disquiet to the horror? It's the watch. It's the exact keeping of time. Such timing was a crucial element of World War I trench warfare. The shelling had to be timed to the second so that the shells would, in theory at least, fall just ahead of the

advancing soldiers, clearing a path through the enemy but leaving the soldiers on one's own side unharmed. In practice, of course, there were many instances where the timing failed to work out, with disastrous results. Mistakes aside, it was, nevertheless, a war of timing. Precise timing.

Learning this fact is akin to the feeling one might have at arriving in Hell and finding out that the lakes of fire and brimstone are crisscrossed by trams running on an extremely tight schedule.

It is said that the commander of German forces at the time of the Battle of Verdun, a man named Erich Georg Anton von Falkenhayn, went into the Battle of Verdun with the precise (there's the word "precise" again) intention of creating a battle of attrition. That's to say, he wasn't looking either to win or to lose the battle. He was, instead, looking to create a scenario that would produce massive numbers of casualties. He was looking to make the French army bleed. Presumably, he understood that his own army would do some bleeding too. That is in the nature of battle. Falkenhayn hoped, surely, that because of his superior tactics, he would cause much more bleeding than he would suffer.

But this very fact, the intentional bleeding that was to be the purpose of the Battle of Verdun, makes it a unique battle, even in terms of World War I, a war which presented us with one surprisingly brutal and devastating and sinister battle after another. Here at Verdun, a matter that was only implicit in previous World War I battles, a matter that you could call

hidden, had suddenly become explicit. With the Battle of Verdun, the war became, self-consciously, a killing machine. If previous battles during World War I had been de facto killing machines, the Battle of Verdun was different in that it was actually designed that way. One can only guess at these things, but it is certainly possible to imagine that, from Falkenhayn's perspective, the killing machine he'd designed at Verdun would have done its job quite effectively if it had lured in and then ground up the entire population of France. In real-world terms, of course, this wasn't going to happen. No battle can kill everyone. But what about that idea, the idea of a single battle that could kill everyone, every single person alive anywhere? Was Falkenhayn, somewhere in his rigorous Prussian brain, exploring, despite himself, the idea of a battle that would kill everyone, that would be, really and truly, the most perfect and thorough battle ever devised, one in which, at the end, everyone is dead? Anyway, whatever Falkenhayn was trying to do, he killed plenty of people.

The Battle of Verdun was designed, as we've pointed out, at least in principle, to do just that. It was designed to kill as many people as possible. Falkenhayn, in his memoirs written after the war, likened the battle to a pump. He thought of the Battle of Verdun as a pump that would bleed the French white. This is a strangely mechanical metaphor, a pump that sucks blood out of bodies. But that, purportedly, is what Falkenhayn imagined.

The Fate of the Animals

It is estimated that the Battle of Verdun caused 375,000 casualties on the French side and 335,000 casualties on the German side for a total of more than 700,000 casualties during just shy of three hundred days of fighting. So, just as Falkenhayn intended, there were more casualties on the French side than on the German side. But one has to believe that Falkenhayn was not imagining a scenario in which his own side, the German side, would suffer more than 300,000 casualties. The bleeding pump, one has to assume, slipped out of his control. Instead of pumping dry the French army, Falkenhayn's strategy ended up bleeding both armies, bleeding them both to the point of exhaustion. This happened with little to justify in terms of ground gained or strategic goals achieved.

Falkenhayn did indeed create a pump for the bleeding of armies. But it was a pump so big that it bled three quarters of a million human beings. It just pumped and bled.

One of the victims of Falkenhayn's bleeding pump was the aforementioned Franz Marc. Marc was German and was, therefore, not one of the intended victims of Falkenhayn's strategy. Marc was also a painter. He was a founding member of the well-known artist group *Der Blaue Reiter* (The Blue Rider). *Der Blaue Reiter* included as members or affiliates, at one time or another, such famous artists as Wassily Kandinsky, August Macke, and Paul Klee. August Macke was also killed during the fighting of World War I. He was killed almost two years earlier than Franz Marc, on September 26, 1914.

Letters written by a soldier

The death of Macke was quite a blow to Franz Marc. On October 23, 1914, Marc wrote to Maria from a town called Hagéville, which is in the Meurthe-et-Moselle department in northeastern France. "The death of August is so terrible for me," Marc wrote, "how can I overcome it inwardly and take a position toward it—the latter quite literally; the naked fact will not enter my head."

2. The horror and grief of World War I bring us closer and closer to a specific painting, a painting made by Franz Marc just before the outbreak of the war, a painting that we're desperate to understand but don't yet know how to.

THE DEATH OF MEN LIKE AUGUST Macke and Franz Marc drives home a certain reality, obvious enough when you consider it. The soldiers who were killed in the battles of World War I were soldiers, but they were also the normal, everyday citizens of Germany and France and England and America and many other countries besides. Young men, mostly. These young men held positions in society of every imaginable kind. They were of the working class and of the aristocracy. Everybody. Some of the people killed at the Battle of Verdun were, like Franz Marc, artists and intellectuals. This is a simple truth of the Battle of Verdun—lots of people of every imaginable kind were put into the bleeding pump. A large cross-section of the male population of Germany and France was fed into the bleeding pump of the Battle of Verdun.

to it just as he was often repelled by it. But that is the nature of all that is *denos*. It both attracts and repels. It is grandeur and horror at once. So, Marc could never call the war bad, he could never condemn the war as such because he was, in a sense, grateful for the war.

4. We delve deeper into Franz Marc and his gratitude for war and also explore his desire to paint even though, for most of his life, Franz Marc was a shitty painter.

WE OUGHT TO LET THIS THOUGHT sink in. From the day he entered the Great War as a new soldier to the day his skull was ripped open by a shell fragment at Verdun, Franz Marc was deeply and profoundly grateful for the war. He was also, it should be said, often in a state of agony and despair. As the New Year came on in early 1916, Marc wrote a letter in which the strain of the war can clearly be detected. "Today we run around with the new face of 1916," he writes to Maria. "The earth is nourished by the bloodiest year of its many-thousand years' existence." This is a terrible metaphor, one that has resonance with Falkenhayn's idea that the Battle of Verdun will be a blood pump, bleeding the French army dry, although Marc would never have heard that metaphor, since Falkenhayn only wrote about it later and never revealed his plans for a blood pump to the troops fighting the battle.

The horror and grief of World War I

We must presume, of course, that men like August Macke and Franz Marc and also men like Erich von Falkenhayn had no great desire to die in the battles of World War I. Nobody said, "Let's all go and die now." I mean, in a way that is hard to put out of one's mind there is, in fact, a strange sense in which people did kind of say, "Let's all go die now." But they didn't actually say it. And we know from Franz Marc that when actual people, people he knew, like August Macke, actually died, it was a shock to his system for which he wasn't prepared. He didn't have the tools even to approach this new reality, the reality where a young and vibrant person could suddenly be dead. We know from Franz Marc's letters that he hoped to survive the war and that, in particular, he hoped to survive the Battle of Verdun. We have the very letter (quoted above) that Franz Marc wrote to his wife on the last day of his life. It is a letter of hope, a letter written by someone who expects to survive the ordeal of war. It is also fair to assume, then, that Franz Marc was not especially enamored of the killing and dying that constitutes war, not on the surface anyway.

Two days after his October 23, 1914 letter to Maria, Marc wrote another letter. It concludes with the lines, "I feel well but very sad. I cannot get over August's death. How much we all lost, it's like a murder; I cannot accept the soldiers' understanding of 'death by enemy hands for the sake of the country,' to which I am normally quite adapted. I suffer terribly from it."

Some version of this suffering must also have affected Erich von Falkenhayn. He did not enjoy killing

and dying, presumably. His design for the bleeding pump of the Battle of Verdun, for all the gruesome imagery that such a metaphor evokes, was not a design for killing just for the sake of killing. Falkenhayn imagined, surely, that his bleeding pump was a mechanism for ending the war. His bleeding pump, we presume, was designed to wear the French army down to the point where the French would throw in the proverbial towel. The French people would have had enough. The politicians would seek an armistice and sue for some kind of peace. The French might declare defeat outright. The French soldiers might revolt and refuse to fight anymore at the sight of so many of their fellow soldiers being bled dry at the Battle of Verdun. These were all possible outcomes of the Battle of Verdun in the mind of Erich von Falkenhayn, we must presume. Falkenhayn makes many claims along these lines, I'm told, in his memoirs, which I have not read, and in tracts he later wrote about World War I and about the Battle of Verdun in particular, which I also have not read.

Falkenhayn was relieved of his duties as head of the German army in August of 1916 by Wilhelm II, largely as a result of the perceived failure of the Battle of Verdun. He began writing almost immediately. Like most military men, he wrote to explain and to justify. He wrote in order to defend his actions for the historical record. Erich von Falkenhayn died in 1922. In his writings over the roughly five-year period between the end of his military duties and his death, he tried to explain that his terrible strategy in the Battle of Verdun

The horror and grief of World War I

was intended to shorten the war. The bleeding pump of Verdun was, in Falkenhayn's eyes, also a pump of mercy. The machine of killing was designed to end the killing.

There was, in fact, a clear logic to Erich von Falkenhayn's strategy at the Battle of Verdun. Sophisticated debates can be had (they've been had and are still being had) about the wisdom of this strategy and about the tactical measures that were applied in order to realize the strategy. These debates are beyond the scope of my own thoughts and, actually, my own interests.

What I do wonder to myself, again, is whether there wasn't another part of Erich von Falkenhayn, a part of himself deeper down and connected to forces of which he could never have been fully aware—forces about which none of us are ever fully aware—that drove him to his plans for a bleeding pump with the knowledge (let's call it a kind of unconscious knowledge) that his pump would become a destroyer of everything, that it was death unleashed, as it were, and that it would cut down Frenchman, German, tree, cow, insect, blade of grass, in short, life itself.

A military strategist I happen to know once opined that my reading and thinking about World War I and the Battle of Verdun in particular had led to my becoming "unhinged," as he put it. "You've strayed far beyond your area of expertise," he said to me. To make matters worse, I revealed to my military strategist friend that the genesis for my thinking about World War I came to me while I was looking at a painting of all things. The painting happens to have been painted by Franz Marc. It

The Fate of the Animals

was painted in 1913, a year before the outbreak of World War I. The painting is known by the title *The Fate of the Animals*.

At first glance, the painting looks like a work of early European abstract art. Lines of color shoot this way and that. The canvas is, indeed, a distillation of all the avant-garde art movements popping up around Europe at the time. You can see evidence of Wassily Kandinsky's musically-inspired, lyrical abstractions in Marc's painting. You can see the harder edge abstraction of Robert and Sophie Delaunay and the coldness, as it were, of Cubo-Futurism. You can see the influence of Russian Constructivism and proto-Suprematism and of Italian Futurism. It is all there in Marc's painting, all the "isms" of early twentieth century European painting.

On closer inspection, however, the painting is not fully abstract. Once your eye becomes accustomed to looking at the work, you see animals. Thus, the title of the painting. There are slashes of pure color and form cutting this way and that, but all of this painterly activity does not happen within a vacuum. The activity is happening somewhere and, more importantly, *to* something. It is happening, you could say, to the animals. And what is happening to those animals is not good.

We know that the fate of the animals is not very good in this painting by Franz Marc because the slashes of color convey an unmistakable sense of violence. The animals (especially the bluish deer in the lower middle of the painting) are in a high degree of distress. The

blue deer is standing with its front left leg raised slightly off the ground and with its head and neck thrown back about as far as they will go. The animal seems to be crying out. It is almost as if the deer is being pierced by one of the yellow-orange shafts of color that shoots through the middle of the painting.

Is the deer being sacrificed? But who is sacrificing the deer, and to what purpose?

3. We learn that Franz Marc, the soldier and painter, was also a lover of happy, joyful cows and that, additionally, he was not a pacifist. We learn, in short, that happy cows and war all fit together somehow in the mind of Franz Marc.

THE FATE OF THE ANIMALS IS AN especially striking painting when you note the fact that not three years before he painted *The Fate of the Animals*, Franz Marc painted *The Yellow Cow*. *The Yellow Cow* portrays one of the happiest and most carefree cows the world has ever seen. The eponymous yellow cow can only be described as romping, an activity in which it is normally very difficult for a fully grown cow to engage. Nevertheless, Marc's yellow cow does, indeed, romp. The yellow cow kicks up her back legs and dances through the landscape. There are also a couple of red cows in the background of the painting and those cows, while not romping and dancing, do seem to be happily and peacefully grazing on a hillside.

Why is Franz Marc's yellow cow so gay? We don't know for sure. The cow does not explain herself. But

Happy cows and war

romping, although unusual when it comes to cows, is not unknown to animals in the field. Any amount of time spent observing animals at their daily business will show that they are sometimes given to sudden acts of romping. Generally, it is true, these romping animals tend to be on the youthful side. But not always. Animals, animals of every kind and age, it turns out, engage in sudden expressions of senseless joy.

In an earlier age, an age such as the one that Franz Marc was born to (he was born in 1880), it was much more common for people from all walks of life to be familiar with animals—at the very least, with the sorts of domesticated animals you can find on a farm. Franz Marc had plenty of experiences where he found himself on foot, in the countryside, observing the actions of cows, sheep, goats, deer, and the like. In the period just before 1911, when Marc painted *The Yellow Cow*, he was spending quite a bit of time in the country, and he was very interested in the behavior of animals. Marc spent the summer of 1905 wandering through the Bavarian Alps. There he began to make sketches of the animals he saw. He was particularly interested, at that time, in sheep. In 1908, he made a chalk drawing of two deer. In 1909, Marc completed an oil painting called *Large Landscape I*. The painting depicts a group of horses gathered at the bottom-right corner of the canvas. Marc had become especially fascinated by horses.

The artistic movement that Marc would become most associated with, *Der Blaue Reiter*, has, as its primary symbol, a man on a blue horse. That symbol was created

by Wassily Kandinsky for the cover of *Der Blaue Reiter* almanac, published in 1912. But the real painter of blue horses was Marc, not Kandinsky. In fact, many people probably associate *Der Blaue Reiter* with the image of a blue horse that can be found in Franz Marc's 1911 painting *Blue Horse I*, even though this horse has no rider and never appeared on the cover of any *Der Blaue Reiter* publication.

Marc, anyway, was firmly a horse artist by 1910, though he continued to draw and paint other animals up until the time of his death. He painted deer, cows, dogs, and foxes, among others. The fascination with animals had deepened, for Marc, from the period around 1905 all the way until his death in 1916. You could say that the entirety of Franz Marc's short artistic career, the roughly ten years from 1905 to 1916, was a matter of painting animals. Marc's was animal art.

One of the things that Marc must have noticed during his observation of animals out in the fields is the suddenness with which they will begin to romp about. It is almost as if a madness has overtaken them. They just turn and jump. Or they spin around. Or they throw themselves up in the air. You would think something might be wrong. But all it takes is a little more watching and it becomes clear that nothing is wrong. The animal is happy. More than happy. The animal is feeling a burst of joy for which there isn't, perhaps, a proper word. Maybe the French word *jouissance* gets the closest. That word captures the sense of transcending limits and the

vaguely sexual, quasi-orgiastic nature of the joy that comes upon animals as they begin to romp.

Marc's *The Yellow Cow* portrays exactly this element of *jouissance*, if we can call it that, in the leap of the cow as she romps through the countryside. Then, just two years later, Marc painted *The Fate of the Animals*. Very soon after that, he was dead—killed, with so many others, on the battlefield around the French town of Verdun.

The obvious interpretation of the development in Marc's art from the painting of animals in their joy and repose to the painting of animals in their terrible fate is that the animals became an allegory for the worsening state of affairs in Europe that finally erupted into World War I. The fate of animals is the fate of Europe. And that fate is very bad.

There is some truth to this obvious point. But it can't be the full truth. Marc cannot have been making paintings that all boiled down to the sentiment "war is bad" or even that Europe had fallen into a disaster. That's because Marc didn't feel this way. Or, let us say that Marc was unsure of his feelings about war in general and specifically about the war in which he ultimately lost his life. Marc felt that World War I contained a deeper meaning. Even as early as September 6, 1914, during his first few weeks of experiencing the actual daily life of a soldier engaged in the Great War, Franz Marc was hinting at these deeper meanings. On that day, September 6, he wrote to Maria about the artillery exchanges he'd been witnessing over

the previous week: "There is something impressive and mystical about these artillery battles."

We can picture Marc there at the foot of the Vosges Mountains watching the explosions from the artillery exchanges back and forth across the lines. He was far enough away from the actual danger during those days that he could watch with some dispassion (though for us, it is an eerie feeling to read of Marc's fascination with artillery fire when we know that it is just such a barrage that will strike him down not two years later). In the early days of the war, the artillery barrages must have seemed to him like a force of nature. This was grand on a grand scale, like a tremendous thunderstorm unleashing noise and light upon the world. This was a man-made version of the great cosmic show.

On September 22, Marc wrote to Maria the following lines: "Around noon I took a delightful ride; the Vosges Mountains have something lovely and peaceful, at times one can no longer believe in the seriousness of this horrible war—until one sees it again with one's own eyes!" Note the exclamation point. Marc calls the war "horrible." But he does not use the word horrible in a fully pejorative sense. He uses the word horrible as one who is deeply impressed. The war is horrible, but it is horrible in the way that all serious things are horrible. Marc does not put it this way, but he might as well have used the ancient Greek adjective *denos*. That which is *denos* is huge and fearsome and powerful and overwhelming. Marc was drawn to what he found *denos* about the Great War. He was drawn

Marc's next words in the letter are: "It is horrible to think of it—and all of this for *nothing*, for the sake of a misunderstanding, for the lack of an opportunity to make yourself *understood* by your neighbor on a human level!" These are the thoughts of a normal human being, a citizen of a country in civilized Europe confused and appalled by the violence that has been unleashed. "And this, in Europe!" Marc writes, practically shouting with indignation on the page.

But Franz Marc cannot remain for very long in the mindset of a normal European concerned with the maintenance of social well-being. Something in him looks beyond. Something resists. Even in the letter, one can feel a hardness of spirit coming over Marc. He resolves himself. He looks up from writing his letter and takes in a deep breath. "It is a lovely New Year's Day," he then writes to his wife Maria, "a little spring air, in which the New Year's bells sound quite movingly." He is preparing himself for the hard thought that is to come. He goes on to write these incredible closing lines: "I do not dislike going into this year," he writes to his wife. "My optimism is indestructible; the lack of optimism is a lack of *strong desires*, and a lack of *will*."

Marc wrote the above lines in the midst of one of the most terrible battles that the world has ever known. Marc revolved around the poles of despair and optimism frequently in the roughly two years that he was a soldier in the Great War. The near breaking points that he endured as a soldier were significant; they shook him. They caused him to believe that something deep and

profound was happening to him. Not just for him, for Franz Marc, but for everyone experiencing the war. He came to believe that the war had to be seen through to the end, whatever that end might be.

On November 16, 1914, Marc got a letter from Kandinsky and also a package with chocolates. Reading the letter and eating the chocolates, a kind of acceptance came over Marc. He realized that he had no desire for the war to be shortened or for the experience to end. He writes to Maria that the war could not end just yet, that it should not end just yet. "The apex has not yet been reached," he writes, "I don't want half-way measures." And then he writes a sentence that must have been difficult for Maria to read. "We must bravely endure the harshness of our times, the spirit of this hour is well worth it." It is almost as if he was willing the war toward the cataclysm of the Battle of Verdun, a cataclysm that he would experience in every dimension and to which he would ultimately sacrifice himself.

Franz Marc, in short, was not a reluctant participant in the tragedy, the inhuman disaster that we call World War I. He was an enthusiast for that war. He wanted the intensity of the conflict to be increased. He was intolerant of "half-way measures." If we are to have war, he was saying, then let us have it in full measure. Let us have a war that is the apotheosis of war, that transforms the world completely, that rips away the veil, that obliterates normal life, and that drags from the wound of this terrible engagement, finally, the Truth.

Gratitude for war

Marc ends his letter of November 16 with the self-contented and lightest of sentences. "A kiss to both of you," he writes. He is feeling quite pleased with himself. He thinks he knows what the war is really about. It has nothing to do with politics or socio-economics. It has little to do with the petty grievances about borders and national interest that constitute the publicly stated causes of the war. The war is, to Marc, about something much, much deeper than that, something to which he can barely put words.

But Marc's most definitive statement about the war, about its "spirit" and "essence," was not in the form of words anyway. It was in the form of painting, in the form of art. More than anything he wrote, we have to understand what Marc saw and understood in the tremendous conflict in which he lost his life through the art he created. We must try to understand it through *The Fate of the Animals* and through Marc's small collection of wartime sketches, sketches that he'd hoped, one day after the war, to use as raw material for a new series of paintings.

In an exchange of letters during the autumn of 1915, Marc attempted to explain to Maria that he was always a painter first, even as he appreciated and understood music and literature. He wrote to her about "seeing" music and literature. She wrote back to him saying that she wasn't sure what he meant. He wrote back again, "It's not amazing that you can't quite understand my 'seeing music and literature'; it's simply the one-sided nature of my painterly talent and, from a literary point

of view, it is of course a flaw; I think it is impossible (at any rate it would be an unfortunate case) that anyone could have an equally *pure* artistic understanding of all kinds of art."

Marc was to write variations on this idea in many letters to Maria. He was interested in the notion that each art is, to some degree, enclosed upon itself. Sculpture, for instance, can only tell you about things that have to do with sculptural issues: mass, weight, shape, heaviness, physical form. Painting is primarily a matter of images. The truths of each medium can communicate beyond their own boundaries, but only to a limited degree. A painter is, therefore, both doomed and privileged to be limited. Marc believed that he "saw" everything as a painter, including other media like music. His vision was a painterly vision.

It is in some sense remarkable that Franz Marc was, in 1915, so easily able to accept the idea that he was fated, as it were, to be a painter first and foremost. This is because Franz Marc was not a very good painter until about 1910. To be more honest, he was a bad painter. To be more honest still, Franz Marc could barely paint. His early drawing was like that of a bad student at an art school. His father despaired of the situation and maybe despised his son for a time. Here was a son who'd declared himself an artist and yet had no talent.

One can sympathize with the father a bit here. It's a shitty situation. Your painter son is a hack who can't paint. Despite this, Marc accepted both the limitations and the responsibilities of being a painter as if these

Gratitude for war

facts were apparent and obvious for everyone, including himself. In actual fact, Marc had only really been making the sorts of paintings that we identify as "Franz Marc paintings" for a few years. He painted the *Yellow Cow* in 1911 and *The Fate of the Animals* in 1913. If you pull back prior to 1911, to paintings like *Horse in a Landscape* in 1910, the Marc we think we know as a painter begins to dissolve.

5. A painter discovers color, really discovers it, really embraces the power and mystery of color, and also, perhaps by extension, discovers the power of fate, of destiny, which is a dangerous power indeed. Heidegger, the Nazi philosopher, makes a brief appearance.

For many years, right up until the moment Marc began to produce works of genius, he was an artist clambering through the fog, trying to find his way in a murky wood. His hand was unsure. He had no sense of color. Literally, he seemed baffled in the face of color. His compositions lacked a sense of purpose or direction. It was terrible.

Then something happened. It happened around 1910. The seeds were there earlier, of course. But still, there was a hard break in the work from before 1910 to the work after. It is a mystery as to why Marc made the leap from artistic confusion to profound vision. There seems no reason, on the face of it. Suddenly, he found

A painter discovers color

the lines between things. He saw the shapes. His animals began to emerge pure and true from the canvas. Color purified too. Red became red. Yellow became yellow. Blue became blue.

Color was the main thing. Such an explosion of color. Primary colors. Red stands out on the canvas directly contrasting with a swath of blue. Many things were happening to Marc in those days. He was looking at the work of the post-Impressionists. He was looking at Gauguin and at Van Gogh. He was seeing the boldness of color in those artists, the willingness to put primary colors right there next to one another, in complete flouting of what the art academies taught. You don't put contrasting colors right there on the canvas, right next to one another. But the Post-Impressionists were doing this. The Fauvists were doing this, those crazed animals. The new abstract painters were doing this. Robert and Sonia Delaunay were doing this and were proud of it. The Delaunays were making purely abstract constructions, spheres and circles and intersecting cones of color. They were painting as if color itself was all you needed, and then they were painting the same shapes and colors from their canvases onto the walls and the baby carriage and then making clothes that looked like those same blocks of geometry and color and calling that whole crazy mix of shit art and reveling in the absolute simultaneity of it all.

Franz Marc looked at all of this color as if looking upon a revelation. It *was* a revelation to him.

The Fate of the Animals

Marc wrote a letter to his friend and fellow painter August Macke in the early part of 1911. "In one short winter," he writes to Macke, "I've become a completely different person." Marc goes on to speak about art in the letter, about finding himself as an artist. Much of this has to do with color and the purity of composition that he'd learned in the previous year. So we can probably make a very precise statement about Marc's art. Putting together the testimony of the art he actually produced and what he wrote about his state of mind in those days, we can say that Franz Marc became an artist in the winter of 1910–11. Something awoke in him, something came together. This means that, unbeknownst to himself, Marc had less than four years to work as a true artist. The true artist's life, for Franz Marc, existed only from 1911 to 1914, since in 1914 he entered the war and was never able to paint again, though he did produce a small series of remarkable drawings in the field. And then he was killed at Verdun. He was a loser for most of his life, then a genius, and then dead.

The thing that woke up within Marc, the thing that gave him the confidence to paint as he did with color and boldness, the thing that allowed him to make his yellow cow and his red cow and his blue horses, this thing that came to life within Marc drove him to paint for only three years and then threw him into the war and then killed him.

Can we really say that? Can we say that something awoke within Franz Marc that made him an artist and that this same force compelled him into the war and

A painter discovers color

led him to the Battle of Verdun where, as we know, he would meet death in the form of a shell fragment? These are hard thoughts.

Can we even name this "something" that "awoke" within Franz Marc? What is this "thing?" What is this "force?" It is very hard to name. We do know, at the very least, that Franz Marc was interested, if not downright preoccupied, with the concept of "fate." We know that his most famous painting was titled *The Fate of the Animals*. We know that in a letter to his wife Maria dated October 28, 1915, on the very eve, as it were, of the Battle of Verdun, a battle that would begin in but a few short months, Marc wrote to Maria that, "*Fate, not the war* is master over our bodies." That's to say fate, or whatever gives fate, whatever is the power behind fate, that is the thing that masters war, that masters the historical events of the time, that masters our own destinies, and that masters even our own physical bodies.

Franz Marc says something else in the letter in which he talks about fate mastering our bodies. He writes to Maria that, "Danger does not exist, only *destiny* does." The word in German here that means both "fate" and "destiny" is *Schicksal*. It is notable that the German philosopher Martin Heidegger, himself a soldier in World War I, though one who, unlike Franz Marc, served behind a desk and not out in the field and on the front lines, but who was, nevertheless, deeply affected and deeply disturbed by his experiences in World War I, so disturbed that he would later choose to become a Nazi because of what he experienced in World War I.

The Fate of the Animals

This same Martin Heidegger, this famous/infamous Nazi philosopher wrote an important philosophical treatise known as *Being in Time* in which one of the important terms is that of destiny or fate, of *Schicksal*.

In that famous work, Heidegger links the word *Schicksal* to the German verb *schicken*, which can be translated as "to send." *Schicksal* then, according to Heidegger, is the "state of being sent." Heidegger further links the word *Schicksal* to his term *Geworfenheit*, which is often translated, rather clumsily, into the English neologism "thrownness." The point here, neologisms and German etymologies aside, is that "fate" and "destiny" are a matter of being carried along, as it were, by a framework that is not chosen by the individual. One does not "choose one's fate" as the common saying goes. Nor is fate a simple bowing down to the arbitrary nature of existence. Fate is not "fatalism."

Fate (*Schicksal*) according to Heidegger—and this thought seems in agreement with what Marc was trying to say in his letter to Maria—the operation of fate, is one in which an individual human being is thrown into a situation that determines him and then that individual must actively become an agent of that very determining. This can be a difficult concept to grasp. It's the idea that to fully become what one is, one must choose the fate, the throwing in, that has already been chosen. One must grasp the situation in which one has already been grasped. One must will what has been willed.

Be careful, of course, because this thought can make you a Nazi, if you happen to think that Nazism is

A painter discovers color

a matter of fate. But the thought can also lead you to become what you always needed to be, whatever that is, which you'll never know until you surrender to it, which is also to make it your own.

6. More is learned about Franz Marc's love of war and color. It's a bit redundant but necessary to my style of writing, which is prolix and doubles back on itself to a fault.

IS THIS WHAT HAPPENED TO FRANZ Marc? Was he grasped, as it were, by the spirit of his time? If so, perhaps this is what made him into a painter and also carried him into the maelstrom that was World War I and the Battle of Verdun. The Battle of Verdun and Marc's sudden and almost-miraculous finding of himself as a painter were, perhaps, tied together as the outcomes of one single "throwing of fate," if we can put it that way. In another letter to Maria, written on January 12, 1916, a letter written with but a few months remaining in Franz Marc's life, Marc wrote the following incredible words: "The war has made everything so clear."

Again and again, Marc describes himself as in a position of "gratitude" toward the war, the war that makes everything so clear. He is in love with the war. At the very same time, he expresses his horror at the war. He is horrified by the war; he considers it a great pity.

Marc's love of war and color

You could argue that these are opposing thoughts that oscillate within the mind of Franz Marc. Or you could say that one thought came upon Marc one day and the other, opposing thought, another day. The problem is that this is not how Marc seems to have viewed the situation.

The fact is, Marc seems to have viewed the war both as a terrible tragedy that had befallen Europe and also as completely necessary. The very fact that the war was a horrible tragedy is the exact reason that Marc loved it so much. The war, to Marc, was the result of a historical trajectory, a historical trajectory much larger and all-encompassing than the diplomatic and military aspects of the conflict. According to Marc, the war was being sent, being thrown into the heart of Europe because Europe had, in fact, allowed itself to continue down a path whereby such a war would be necessary.

The war itself was not to blame, Marc seemed to be saying. The war, at its deepest level, had nothing to do with politics or diplomacy or the functioning of nation states with their particular interests. The war was a surface phenomenon. The war was but the result of a process much deeper than anything detectable at the surface. The war, the deep causes of the war, reached downward, ever downward into the soul of the world, you might say. Down there, at the roots of the war, lay a kind of personal and collective guilt.

"Nothing," Franz Marc wrote to Maria on February 2, 1916 (and he is writing these lines less than three weeks before the inception of the Battle of Verdun, a single

battle that will claim almost three quarters of a million human beings as casualties and take nearly a full year to complete, a battle in which Franz Marc himself will be tested in every way imaginable and then killed, and yet still, only three weeks before the inception of this battle, a battle that Marc must have felt coming, must have known in his bones was just on the horizon), "Nothing is more a matter of course or deserving of punishment than this war is."

We should not hate the war, Franz Marc tells Maria. If anything, we should hate ourselves. We are the ones who have prepared the way for this war. The war did not simply come upon us, like something stumbled over in the woods. The war, thought Marc, was the necessary result of how we have been living. The war is not something foreign, Marc argues, or something that could have been avoided. It is not something that came into the life of Europeans from outside. It is no strange mistake, no bumbling of generals and politicians. The war, Marc tells his fellow Europeans, is our own. "Nobody sees that," Marc laments to Maria in that same letter. "At least nobody wants to see it as *his own* guilt."

The difference, then, between the mostly confused and utterly forgettable paintings and drawings that Franz Marc made before 1910, the bad paintings of an idiot, and the utterly unforgettable, undeniably vital works that Marc created from 1910 until he became a soldier in 1914, is the difference between a painter who had connected with his world, truly connected with the reality around him, horrible and plunging-toward-tragedy as that

Marc's love of war and color

reality was, and a painter who was still drifting at the peripheries of that world trying to find his way in. In the winter of 1910, Franz Marc found his way into the world. Or, to put it another way, the world found its way into Franz Marc. Did the world penetrate Marc or did he penetrate the world? There is a truth to both ways of looking at it. Something penetrates Franz Marc from the outside, and, simultaneously, some aspect of Franz Marc finally breaks through. So he is both penetrated and penetrator.

One of the things, as we've already noted, that Franz Marc discovered in the winter of 1910, truly discovered, as if for the first time, was color. All painters are, of course, using color all of the time. In some basic way paint is just color—sticky color. Even the painters who use no color, who work only in black and white, are using color in the sense that their rejection of color is, itself, a dependence upon what has been rejected. Franz Marc's works before 1910 cannot even be said to utilize color in this negative fashion. Franz Marc's paintings before 1910 are painted by an artist who uses color but has not yet figured out why. Those paintings utilize color as if color is the thing that you add to a painting to complete the painting. He was painting with the careless assumption that an artist uses color to color things in, as it were. He doesn't get it at all. His thought is like this: First you organize your painting, you structure it, you block out the forms and lines, and then you add the color as the final touch. Color here is an addendum, an afterthought.

The Fate of the Animals

There are, in fact, great painters who have painted this way. To be crudely reductionist, we can say that for such painters, line comes first. They are painters deeply attuned to the natural joints between things, you might say. Color, for these sorts of painters, is useful only insofar as it helps delineate the line. This is a gross oversimplification, of course, since there are very few painters who are utterly and completely dedicated to the line just as there are very few, if any, painters who are completely and totally dedicated to color. For most painters, there is a balance to be achieved, and this balance, specific to each particular painter, might fall more to the side of line or more to the side of color. There are many other factors to be considered as well, I'm sure. But there was a moment, for Franz Marc, when the full possibility of color took hold in him.

Marc adopted a theory of color. The theory is not very interesting in itself. It could even be called stupid. It was a symbolic theory extrapolated from a mixture of the scientific analysis of light and color that had been going on in the late nineteenth and very early twentieth centuries along with studies in color and color theory taken up by painters themselves: the Impressionists, the Neo-Impressionists, the early abstract painters. The years of Franz Marc's lifetime, those years between the last decades of the nineteen hundreds and the opening decades of the twentieth century, saw an explosion of interest in color, in plumbing its possibilities, in experimenting.

Marc's love of war and color

These explorations of color were happening just around the time that Franz Marc was having his artistic awakening. Marc looked back to Cezanne and Gauguin and Van Gogh in particular. He also looked directly around him, at the paintings being created by those artists literally at work in their studies hour by hour, minute by minute, as Marc himself was experimenting on his own canvases. The importance of Marc's friendship both with Wassily Kandinsky and August Macke cannot be underestimated here, nor can his important confrontation with the paintings of the Delaunays, nor can his friendship with Paul Klee, which, while less intimate than that with Kandinsky or Macke, was influential in Marc's development during his *annus mirabilis*, the miraculous year that spans the winter of 1910–11. Somehow color kicked him in the head, knocked him around a bit. He emerged like a new man, the stupidity dropped from his being, and he was suddenly an artist in love with color.

7. What is an *annus mirabilis*? (Hint: It is not about having a nice time; it is about suffering. Marc suffers and then surrenders to his fate. And then the Spirit comes to him in the form of a horse.)

ONE THING TO MAKE CLEAR RIGHT away is that in no way can an *annus mirabilis* be thought of as a "great year" or a "lucky time," as the popular usage of the phrase implies. An *annus mirabilis* is not a year of successes or of winning lots of prizes. Worldly success has nothing to do with it. An *annus mirabilis* is, actually, a year of great turmoil and distress, a year of near disaster when *something is made clear*. An *annus mirabilis* is a confronting of the abyss, by which one emerges, suddenly, with a new sense of reality.

In the winter of 1910–11, Marc experienced his *annus mirabilis* because he came to understand what he was and what he was not as a painter. Marc's *annus mirabilis* caused him to see painting in an entirely new way. It caused him to see painting as a tool for thrusting aside what is inessential and penetrating to the root of what

What is an *annus mirabilis*?

is most essential. Painting became for Franz Marc, after his crucible year of the winter of 1910–11 and the *annus mirabilis* that it represents, a tool by which he could cut to the very root of everything.

The difference between his previous style of painting and Marc's "root painting" is easy to see. Marc began to paint animals with primary colors. Cows in the world are not, as everyone knows, yellow or red. Marc painted his cows red and yellow, and painted his deer and his horses blue, for the very reason that they are not yellow or red or blue in the visible world. This is the whole point of the artist's group being called *Der Blaue Reiter*. Painting a horse and its rider blue severs the mode of looking that happens in the real world from the mode of looking that happens in a painting. With blue horses, we aren't looking at a reproduction, a representation of the visual world as we see it when we look with our eyes upon the world. In Marc's paintings after 1910 (or Kandinsky's, or Paul Klee's, for that matter), the job of painting is not to give us a realistic and plausible illusion within a frame, whereby we look at a painting as we might glance out of a window. The frame of a painting by Franz Marc does not frame a primarily visual experience. Instead, the painting frames what Marc and Kandinsky were quite comfortable calling a "spiritual experience."

Do you understand that? Are you willing to try to understand that?

The German word for spiritual is the adjective *geistig*, which comes from the noun *Geist*. The word

"spirit" and the word *Geist* share many overlaps in terms of meaning and nuance. There is, however, one aspect of the word *Geist* that is not captured so well in the English word "spirit." This is the sense of "mind." Not "brain" but "mind." A painting that we are meant to apprehend, to view in a *geistig* way, in a spiritual way, is a painting that isn't looked at primarily with the eyes so much as it is taken in by the spirit and the mind. The blueness of the horse does not tell us anything about the literal blueness of horses in the world.

Nor is it meant as a statement of the absurd. Marc and Kandinsky did not see themselves as playing games with color or shocking our sensibilities just for the sake of shock. You don't look at a painting by Franz Marc in order to acquire visual information about how cows or horses look out in the fields. You don't go to the paintings for anatomical information about animals. You go to the paintings to have an experience that may start in the eyes, but does not end in the eyes. The experience is meant, primarily, to be *geistig*. Franz Marc, in short, was trying, through his paintings, to show us something deeper about the world of animals, the world of living things, than what we might otherwise see. He was trying to use the surface of a painting, the pigmented colors smeared onto a flat surface, as a way to go much deeper, beyond that which is visible altogether. He was using flatness as a medium for depth, for reaching down into the roots.

Marc painted horses blue because the color blue carries with it a certain power and a certain resonance.

What is an *annus mirabilis*?

The "color power," if we can call it that, of blue was to Marc a quality that somehow inheres within the color itself. That's to say, Franz Marc believed that the color blue is infused with spiritual properties, with *geistig* properties. The mind, the Spirit, *der Geist*, picks up on the *geistig* quality of the color blue and grabs at the "essence" of blueness, as it were, carrying that essential quality, the quality of "cool power," and associating that cool power with the inner nature, the not-immediately-apparent underlying essence of horses, the way that horses inhabit their world and then make apparent, simply by their existence and persistence as horses, the cool power that makes horses horses.

The blueness of horses is not a visual truth about horses but rather, to the mind of Franz Marc, a deeper and verifiable truth, an important and crucial truth of what horse-being brings into the world. You're not getting horses if you don't get their essential blueness, is what Marc is saying with his paintings, showing with his paintings. That's not to say, by the way, that horses are only understood through their blueness. Marc sometimes painted horses as red or yellow. These colors get at other truths of the horse and the being of the horse. But when you paint a horse blue, you are showing that the horse is deeply in touch with a cool power that is essential to one aspect of what it is to be a horse. Horses, by their special quality of being ancient creatures, powerful creatures, useful creatures but also proud and sensitive creatures, by their grace and by their hooves that pound the earth and by the flowing manes that take

The Fate of the Animals

the wind just so, these creatures, it seemed obvious to Marc, are manifesting a kind of deep, essential, at-the-root blueness that can never be "seen" as such but that can easily be "known" by the operations of mind and of spirit, by the operation of *Geist*.

8. We encounter in Philadelphia a strange man in a bookstore who is probably an angel (or demon) and who introduces to us a book. That book brings D.H. Lawrence into the picture, and that's a problem.

SOME YEARS AFTER HAVING BECOME preoccupied—one might even say obsessed—with the painting known as *The Fate of the Animals* by Franz Marc, I came across a book, by chance, perusing the stacks of a used bookstore while visiting the beautiful and depressing city of Philadelphia. The cover of the book caught my eye. It featured a color reproduction of *The Fate of the Animals* and then the title *The Apocalyptic Vision: The Art of Franz Marc as German Expressionism*. The book was written by a scholar named Frederick S. Levine in 1979. It was published by Icon Editions, an imprint at the time of Harper & Row Publishers.

When I carried the book to the proprietor of this little used bookstore on a side street in Philadelphia, intending to purchase it, he looked up for a moment from a notebook into which he was entering a column

of numbers. He glanced up, his eyes visible just above the rims of his glasses, and gave me a solemn nod. No words were exchanged. His nod simply conveyed the quality of solemnity. Was this man a prophet or an angel? I don't know. Was he really paying attention to the book I was buying? I don't know. Did that bookshop even actually exist? I think so.

The nod from this person at the store, the person who may not have even been a human being, may have been a celestial figure of some sort or, perhaps, a being from the underworld, a demon as they used to say, whoever he was, whatever he was, the nod made an impression on me, though I soon forgot about it. His nod, as I think about it in retrospect, conveyed unmistakably the following message: "Good, you have chosen the correct book." The book then sat on my bookshelf for more than a year. We never want to accept the fate that we have actually been given. I did not want to accept my fate and therefore proceeded to ignore the book. Then, one day, I grabbed the book from my bookshelf for no particular reason. I came across a passage.

In the passage in question, Professor Levine writes of Franz Marc's commitment to painting animals and to painting horses in particular. Levine mentions Marc's paintings *Small Blue Horses* and *Large Blue Horses* (both from 1911), and *Small Yellow Horses* from 1912, and, as Levine puts it, "ultimately" *The Tower of Blue Horses* of 1913. The *Tower of Blue Horses* does indeed tower, both in its relation to Marc's thoughts about color and about animals and also to what Levine calls the "apocalyptic"

A strange man in a bookstore

strain in all of Franz Marc's work. This apocalyptic strain has something to do with animals. Levine references a quote from Carl Jung to the effect that "the animal has always symbolized the psychic sphere in man which lies hidden in the darkness of the body's instinctual life."

Professor Levine goes on to quote D.H. Lawrence, specifically from the strange and interesting book Lawrence wrote near the end of his life, a book titled *Apocalypse*, which is ostensibly about the book of Revelation. And it really should be noted, by the way, that Lawrence's *Apocalypse* truly is a singular book. It is a nasty and mean-spirited book in many ways, as are all the books of D.H. Lawrence, at least to some degree. Lawrence could not be Lawrence without expelling a certain amount of nastiness. That's the cost of reading Lawrence. You have to deal with the bile. You have to deal with the ugliness. Should you? That's up to you.

Here's what Lawrence says the book of Revelation is all about: He says it boils down to the basic idea that "the weak and pseudo-humble are going to wipe all worldly power, glory, and riches off the face of the earth, and then they, the truly weak, are going to reign." I suppose that this is, actually, a pretty fair one-line summary of the book of Revelation. When you put it that way, Lawrence's way, it really doesn't sound all that great. But that's what religion stands for today, Lawrence says. It stands for letting the pseudo-humble reign. Part of the point of Lawrence's *Apocalypse* is thus to reveal for us the crazy and rage-filled and weak and

resentful brain of John of Patmos, who, purportedly, wrote the book of Revelation.

But that's not Professor Levine's specific interest in Lawrence's book. Levine is interested in what Lawrence, in a kind of semi-Jungian insight, has to say about horses and the way that horses have always been a representation of various yearnings and forces in the human psyche and:

> How the horse dominated the mind
> Of the early years, ...
> You were a lord if you had a horse....
> He is the dominant
> Symbol: he gives us lordship: he links us, ...
> With the ruddy glowing Almighty of potence:
> He is the beginning even of our godhead in the flesh.
> And as a symbol he
> Roams the dark underworld meadows of the
> soul....

Franz Marc, according to Frederick S. Levine, was moved to paint horses by exactly these same symbolic potencies that D.H. Lawrence describes in the above passage. The horse symbolizing, as Levine argues, all that Franz Marc "was not but which he longed to be."

This thought by Professor Levine amounts to the claim that Marc painted animals, and horses in particular, because in some deep sense he wanted to *be* an animal, and specifically, to be a horse. That's to say, he wanted to live with the purity of action and instinct that constitutes animal life. He wanted, maybe, to have the freedom from civilizational constraints by which he

might suddenly leap about on the hillside like one of his yellow cows.

Marc himself suggests something like this in a letter he wrote to Maria on April 12, 1915. "The spirit in modern centuries," Marc wrote, "full of vanity concerning the idea of progress, is too opposed to the art we dream of." The antidote to this modern vanity regarding progress, Marc writes to Maria, is to be found in "instinct." "I mean especially," Marc writes in the same letter, "that instinct which guided me away from the life-sensation of man toward a feeling for the 'animalistic,' toward the 'pure animal.'" Marc goes on to claim in the letter that the "'feeling of life' of animals made everything that is good in me become sound."

This sounds very much like the hidden, animalistic "psychic sphere" that Carl Jung discusses as well as the horse, roaming the "dark underworld meadows of the soul" that Lawrence writes about in *Apocalypse*. Marc, according to Frederick S. Levine, is thus very much in the trajectory of Jung and Lawrence in his desire to cast off what is called "civilized" in man but is actually a kind of sickness, and to return to that which is "animalistic" and "primal" but is actually a kind of health.

But there is an element of Franz Marc's art that resists this line of thinking. This is the element of abstraction. Abstraction in painting was something new and forward-looking for Marc, something that had become possible only in the bosom of the otherwise-sickly modern world. And the element of abstraction gets stronger in Marc's work after the *annus mirabilis* of

The Fate of the Animals

1910–11, not weaker. Look at a painting like *Blue Horses* from 1911, for instance (also known as *The Large Blue Horses* [*Die grossen blauen Pferde*]). The painting is awash in the primary colors that Marc adopted in his mature painting style. Blue horses. Red hills. A swath or two of yellow on the horizon. It is a radical painting in terms of color. But there is still something naturalistic about the rendering of the blue horses. The horses are becoming quite geometric, getting very circular, no doubt. They are verging into the territory of pure geometry. But Marc has also taken great care to make the horses still horse-like. They've got horse manes and horse snouts. The picture plane gives these blue horses all the space they need to be horses.

Contrast this with *Stables* from 1913. In *Stables*, the horses don't get much space to be horses at all. They have broken down into planes and cones and rays and other geometric elements. There is a more or less intact and identifiable horse body at the top left of the painting. But that's it. Otherwise, the horses have become abstractions.

Stables, in short, is not a study in the instinctual. It is more like a study in the geometric realities that are otherwise hidden in the organic reality of a living horse. It is a study in the reality behind reality, if we can put it that way. It is a study in foundations—visual, structural, psychical foundations. It is a painting not about the horse as a primal beast, but about the primal forces that produce, among other things, horses. Those deeper primal forces, those rays and lines and blocks of color,

A strange man in a bookstore

give being to all things, you might say, and become in this or that instance a deer, a fox, a man, a horse.

9. We're in the midst of a battle now, between D.H. Lawrence and Franz Marc, around the question of what it means truly to be alive. Who will win? It comes down, as it so often does when you get into it with Lawrence, to the question of fucking and how to do it right.

IT IS NOT EXACTLY, THEREFORE, THAT Franz Marc wanted to liberate himself from the strictures of civilization and become free like an animal, like a wild horse. He didn't want to strip his clothes off and go running around in the forest. Marc liked clothing. He looked good in his uniform, by all accounts. It's more that he saw in the forms and shapes and expressions of animals, in their unselfconscious ability just to be what they are, the more primal and originary force of life giving expression to itself.

Professor Levine's comparisons between Marc and Lawrence don't quite, then, get at the difference between the two men. Franz Marc, as a person, had none of the longings for the instinctual that drove Lawrence

in his most frenzied prose, and in his desire to merge the sexual and the animal and to push away all that had become, in the mind of D.H. Lawrence, sick and overly refined and deathly in modern man. For much of his life, it seems, D.H. Lawrence was interested in transforming himself from a modern man into something more like an animal, to live in the animalistic embrace of whatever you are feeling or are impelled toward at the moment.

Marc had no such desires. Franz Marc, by contrast with D.H. Lawrence, was in fact deeply interested in the concept of purity, of purifying man and of purifying the spirit, concepts that were inimical to D.H. Lawrence down to his very root and which he, D.H. Lawrence, railed against in many of his novels and in his letters and in his diatribes, like the strange text *Apocalypse*, quoted from above.

While D.H. Lawrence and Franz Marc may have agreed in many of their diagnoses of the ills and maladies that beset modern man, they would have quickly diverged in their sense of what is *geistig*, what is truly of the spirit and what must be revealed through art. It is important to think this through because there is so much that is similar in Marc and Lawrence. There is so much that they would have agreed on. But there is also a crucial and core difference. To understand the similarities and the crucial differences between Marc and Lawrence is to begin to penetrate to the very core of what Franz Marc thought that art should do in the world, what it should reveal.

The Fate of the Animals

Lawrence had the desire to reveal what is animal and what is instinctual—and therefore vital and powerfully living—in man. Marc had the completely different desire to reveal what is *geistig* and spiritual under the surface of the animal and to show that this spiritual, this *geistig* essence is at the root of what makes the animal and the human more precisely and more deeply what-it-is. It would be fair, therefore, to characterize D.H. Lawrence as a kind of primitivist and as an enthusiast for what is natural, vital, the instincts unsullied by the constraints of civilization.

It would be accurate to label Marc as a kind of essentialist, for whom the primitive could sometimes reveal qualities of the essential, but not always. Marc was not interested in the primitive as such, nor in the animalistic and the sensual as such. He was interested in the primitive and the sensual as a waystation along the path toward a deeper truth.

Franz Marc was interested in penetrating the veil of appearances in order to find that which is truer than nature, truer than the seeming vitalism that confronts us even when we observe animals in their natural settings. It was not the behavior of the animals, as such, that moved Franz Marc, not their natural and instinctual ways as such (even though he could appreciate such naturalism and instincts) but what lay behind the appearances, as it were, what was being shown to us about the essences, the real truth of animals and all living things.

In this, you could say that Franz Marc was very much a metaphysical painter, a metaphysical painter

In the midst of a battle now

as someone who looked beyond the physical realm in a way that D.H. Lawrence fought, his entire life, not to do. D.H. Lawrence saw the here and now, with all its passions and strivings, as *itself* the spiritual realm, the place of *Geist* in and of itself. Franz Marc, too, was always interested in bodies, in physical form, in materiality. It is, after all, only in living bodies that we confront the force of life itself. In this Marc and Lawrence are in agreement. If you are interested in life, you have to confront the life force as it is manifest in actual living things, in plants and animals, in bugs and people, in the things all around us that grow and die. That's where life is. Not somewhere else. And yet, the life force—if we can call it that—that Lawrence was seeking to express in his literature and the life force that Franz Marc was attempting to reveal in his paintings were, in the end, not the same thing.

For Lawrence, man is a creature of intuitions and passions, and those passions always take us *back* to the body. The deepest things, for Lawrence, are always the most surface things—rediscovered, as it were. Lawrence wanted us all to stay at the surface of life, but to engage with the surface in the deepest of ways, if this makes sense. Most people fail to do this, he thought. It is possible, for D.H. Lawrence, to be moved by the love of a woman and to take that woman in a sexual way, to pursue the woman and to finally take her sexually and still to have never had an experience at all. (This is Lawrence's language, by the way, a language in which male sexual energy is always taking and overcoming the

female, and the female is always at war with herself in wanting to be taken but also not wanting to be taken. There is much to object to in this language, but that, again, is Lawrence.)

It is possible for human beings to live in a kind of stupor, an unwillingness to take their own experiences as truly their own. Fucking alone is not enough, even for Lawrence. Even for Lawrence, there is a sort of fucking that isn't getting it right. Real fucking should make you feel crazy and alive and filled with something barely containable. But most fucking, Lawrence would surely have said, is a kind of perfunctory gyrating of the hips, an embarrassed commingling gone through with in a more or less zombified state. Most fucking is, in fact, quite boring, which to Lawrence was a thought so depressing as to make him side, almost, with John of Patmos. If the fucking of human beings is going to be so utterly and perfunctorily boring as this, Lawrence more or less told us in many of his writings, then we might as well side with John of Patmos and blow the whole place to smithereens.

10. More on fucking (I don't seem to be able to let it go) and then on to pissing (the vulgarities multiply) and then finally on to Jesus Christ.

IT CAN BE HARD TO DIFFERENTIATE THE truly awake person from the sleepwalking person. The person who has woken up, the person who is alive to their own passions is, at the very same time, living in the same world as the sleeping person, the person in the stupor, which is, for Lawrence, most people. The world doesn't become a completely different thing for the awake person or for the sleeping person, it is the same world always. What changes is our willingness to accept that world, to grab onto the physicality and viscerality of life with both hands, and to willingly drown in the surfaces of the world, as it were.

That helps to explain why D.H. Lawrence was so inordinately fond of fucking. (Though we should mention that Lawrence became notably less fond of fucking, even somewhat disgusted with it, in his final years, years filled with disease, bodily breakdown, and depression. Perhaps he was simply worn out. He was exhausted by the fucking both in its actuality and in the

idea of it. But he was still committed, philosophically speaking, to fucking as the truth of life even unto his last and dying days.) Love, for D.H. Lawrence during most of his life, simply made no sense without the fucking. We are physical creatures. There is love. It draws us together. But what is this togetherness if the togetherness is not, itself, physical? That's what Lawrence would have asked of all of us. How do you confirm the material nature of your own self in love without the concomitant fucking? The concomitant fucking, if we can put it that way, is the proof and the confirmation that love is a real, worldly, and physical thing.

In this, D.H. Lawrence was an anti-Platonist in every fiber of his being. Physical love was not the lowest level of loving for D.H. Lawrence, not the bottom rung of a ladder that sets off an ascent which ultimately leaves the body behind. The only kind of love is real love, and the only kind of real love is a fucking love, D.H. Lawrence would have said. In essence, this is exactly what D.H. Lawrence is saying in most of his novels.

This thought would have been considered quite base and unacceptable to Franz Marc. That's not to say that Marc refrained from fucking. As far as we know, Franz Marc did engage in the activity of wife-fucking, and other forms of fucking as well. It may be the case that Franz Marc lived, for a time, in a kind of *ménage à trois* with his first wife and his second wife (the Maria of his World War I letters), and this ménage may have been, among other things, an act of sexual libertinage for all three of them. Marc was not well-disposed

More on fucking

toward bourgeois morality. Marc considered bourgeois morality to be largely a matter of hypocrisy. In this he was in the same camp as many of his contemporaries in the artistic and intellectual milieu. But Franz Marc put no great stock in the power of sexual libertinage as such. He did not feel that sexuality was the key to anything. He did not think he could fuck his way to the truth.

Marc felt within himself the highest calling, as it were, to purity and to abstraction. He concentrated on the physicality of the physical world in order that he might be able to penetrate that mere physicality. In a letter to Maria written from a guardroom in Mühlhausen on Christmas Eve, Franz Marc penned the following thoughts: "The smallest bit of news in the paper, the most ordinary conversations I listen to, have a secret double meaning for me; there is always something behind them; behind everything there is something more; once you have developed an eye or ear for this, it never leaves you in peace. And the eye! More and more I look behind—or better—through things, to find something hidden behind its outer appearance, often in a subtle way, by deceiving man with something quite different from what they actually hide."

Aspects of this thought might very well have caught D.H. Lawrence's fancy. He might have been intrigued by the idea of "doubleness" and "secret meanings." This, again, is the complexity of comparing the Lawrence view of the world with the Marc view of the world. We have to do it, because we have to understand how easy it would be to say that Marc was painting his way to some

kind of Lawrentian truth. But in the end, neither Marc nor Lawrence would have seen it that way. In the end, D.H. Lawrence could not have accepted Marc's claim that appearances carry us, in their truth, far away from appearances. He would not have accepted the idea of looking "behind" or "through" things to find that which is so hidden it is therefore contrary to the meaning and purpose presented to us by outer appearances.

Lawrence might, indeed, have turned around the entire metaphor. Lawrence more probably would have said that the appearances are deceiving only insofar as they give us the false hope, the illusion, that there might be some secret truth hiding behind. Once we accept the appearances *as* appearances, Lawrence would have said, once we do that, only then have we discovered the real secret. The real secret is that there is no secret. The real secret is that we have everything we need in these bodies and in the needs of these bodies just as they are and as they seem. This is a spiritual truth, a *geistig* truth, insofar as there is any *geistig* truth, Lawrence might have said. We are creatures of the body, Lawrence kept telling us in all of his writings, and of the needs of the body, and these needs must be satisfied, by eating and by fucking and by pissing and by shitting, and it is the creature who does so in full lusty honesty who has reached the highest level of *Geist*, of spiritual truth. That's D.H. Lawrence.

Franz Marc was not at all like D.H. Lawrence in this regard. Franz Marc would not have been amused, for instance, by D.H. Lawrence's painting that shows a man standing by a wall in a garden, completely naked,

More on fucking

pissing into the weeds. "That's the painting of reality," Lawrence says to us, pointing at his painting of the pissing man, the stream of urine arcing from the penis of the man down to the weeds and the ground. "That's a human being in his full physicality, no lies. Every other kind of painting, every other kind of art-making is a lie."

But there is no question that Franz Marc would have looked at D.H. Lawrence's painting of the pissing man and been disgusted by the rendering of reality that so resolutely refuses to penetrate reality, by the evoking of physicality that refuses to see the deeper *geistig* truths to which our senses give us access but which are not available to physicality, to materiality as such. Writing to Maria one day on November 21, 1915, Franz Marc reminded his wife that, "There is only one idea that is always decisive: the world, the 'physical wandering,' doesn't touch us, since we don't look at the visible, but at the invisible." What was decisive for Franz Marc would have been utterly incomprehensible to D.H. Lawrence.

It is, nevertheless, an open question as to whether a medium so undeniably visual as painting is able to show, or to invoke, the invisible. At the very least, there is a trick, or a double game, going on with the verb "to see" here. As we've encountered in the quote from Marc about hearing and seeing, Marc understood that seeing could sometimes be seeing without really seeing. There is another way of seeing that is really seeing. That's to say, there is false seeing and there is true seeing. Or there is empty seeing and there is rich seeing. Or there is surface seeing and there is deep seeing.

The Fate of the Animals

This hearkens back to the Gospel stories, the places where Jesus spits in his hands and cures the blindness of some man, rubs his spit and some dust and mud around the face of some fellow suffering from blindness, and then that person is suddenly cured and can see again. Then Jesus generally asks whether the person can really see. "Sure, I've cured your physical blindness, or some other malady," Jesus will claim, "but let's now think about what the true definition of blindness, or lameness, or physical disability really is." What Jesus suggests is that the lack of physical capacity is but a clue to the lack of spiritual capacity—*geistig* capacity, if you will.

Not that we should ignore the body. We are the body—Jesus admits this. He treats of the body. But Jesus is frequently frustrated by those who want to remain on the level of the body without grasping the deeper significance. "I'm not opening your eyes so that you can see," Jesus seems to be telling them, "I am *opening your eyes* so that *you can see*."

Jesus is, as it were, reaching into the bodily being of the people that he meets in order to open a path to spiritual being, to *geistig* being. His frustration, the constant frustration of Jesus in the Gospel stories, is that only rarely do any of those who follow him around, including his own chosen disciples, seem to be able to make the jump between the physical acts of healing and resuscitating, all of the so-called miracles, rarely can anyone make the jump between the miracles of Jesus Christ and the transformation of mind and spirit

More on fucking

(the *geistig* turning, if you will) toward which Jesus encourages these people.

The being that is body-being, Jesus seems to be telling everyone, is only worthwhile, is only truly what-it-is, when the body-being is opened up to the spirit-being. This kind of stuff is all over the Bible, actually, the idea that one can hear without hearing, see without seeing, and that the spiritual task is to transform one's body into an instrument of true hearing and of true seeing, to turn one's being to the being that is fundamentally open versus one that is closed.

Writing to his wife Maria about a book called *Emanuel Quint*, a book by Gerhart Hauptmann that Franz Marc carried with him onto the battlefields of World War I and was reading in the winter of 1915, not four months before his death, the full title of which is *The Fool in Christ: Emanuel Quint*, Franz Marc writes to Maria that the protagonist of that novel, "lives only for his own humiliation in the face of the world and thus finds his liberation; he does not *want* to help men physically and make them satisfied and healthy; his soul, directed toward the spiritual, the invisible, is painfully frightened by this demand, a demand which, to his disappointment, he reads time and again in people's eyes. This is the world's great misunderstanding of Christ."

11. In which we contrast painting that tries to copy how things look, and is therefore mostly silly, and painting that tries to reveal an inner truth about how things really are, which is getting somewhere.

S O, WE CAN SEE THAT FRANZ MARC was himself aware of the fact that his disavowal of the visual in the visual medium of painting was deeply connected to Christ's curing of people's bodies that is meant, though rarely understood, to be a vehicle by which he might gain access to their souls.

There is, in short, an almost perverse pleasure that Franz Marc seems to take in using the resolutely visual medium of painting—a medium in which one uses one's eyes to look directly at what is portrayed on the canvas—in order to force us beyond and behind what the eyes can see. Franz Marc's response to the charge of perversity might very well be something like, "What other choice do I have?" This is, actually, not unlike the implied response by Jesus Christ to those who might wonder why he performed all of those so-called

Painting that tries to reveal an inner truth

miracles, given that the miracles were a distraction from what he was really trying to show people. Christ was trying to stimulate a *geistig* transformation in those with whom he had contact and, more often than not, the bystanders got caught up in the razzmatazz. Why, then, engage in the razzmatazz at all?

Jesus, the purported Christ, has only one real answer to this reasonable question. His answer must be, "Because I had no other choice." "Here they are," Jesus says, "physical bodies, living human beings all around me. I speak to them with my words, going into their ears. I touch them with my hands, going into their bodies. In what other way would you have me penetrate them?" Jesus might very well ask. "What are these living beings all around us anyway? What are they but creatures of flesh and blood, with ears and eyes and mouths and hands? What are they but eating and talking beings, who shit and piss and fuck and die?" With this, D.H. Lawrence would very much agree. D.H. Lawrence, Franz Marc, and Jesus the Christ would all be in total agreement on this one point of vast spiritual importance.

But you cannot take physicality as mere physicality, Jesus would say, and here D.H. Lawrence would (and did) part company with the man and with the thought. Franz Marc, however, would (and did) not. Franz Marc stayed to listen. Franz Marc heard in that sentiment by Jesus exactly what his own heart had told him about painting and what it can and should do. By being physical, by being marks of color on a flat surface, painting is, in a strange and counterintuitive way, in

its resolute material and surface nature, the perfect medium for conveying spiritual truths, for bringing us beyond what can be seen by the eyes in their blindness and for bringing us to what *Geist* sees by being attuned not to the visible, but to the invisible.

What is the point, Franz Marc might ask us, what is the point anyway in looking at a perfect painterly rendition, a careful subterfuge, a nicely illusionistic portrayal by means of this or that painterly trick of shading and color and perspective? What's the point of looking at an image that renders in two dimensions what we can see in the world just by looking out at it with our own two eyes? Why the reduplication? Why replicate the world as it looks, exactly as it looks, on a two-dimensional surface so that we can see it again in a gallery or in a museum? How amazing, we say. What a wonderful thing, to see on a framed surface that which is there, right outside, if we just leave the gallery or the museum and go out into the world and look. Yep, we say, impressed by the doubling images of the world that we've already seen. Yep, we say, that's it. The world looks just like that. There it is.

What is it that we actually enjoy in paintings like this, Franz Marc would have asked us? Do we enjoy the metaphysical confirmation, as it were? Does the reduplication of the world, its remaking on a two-dimensional canvas, does it help to cure some lingering doubts we might harbor about whether the world really is the stable and selfsame place, the place of real metaphysical solidities that we hope it to be. When

Painting that tries to reveal an inner truth

we look at a painting that shows us the world exactly as we think we see it, do we feel confirmed and further grounded in that world? Yes, we say, there it is. There it is a second time, which must prove that it was really there the first time.

This redoubling of the world on the canvas, Franz Marc would say to us, is not only a rather silly thing to do, but also a measure of our stupidity and of our cowardice. The desire to have our world confirmed in the stupid reduplication of the way it looks exactly, this is the desire to bury our head in the sand, Marc would say to us. It is the desire to hide, to hide in the surface because we are afraid of what the depths might reveal. It is the desire to say that there is no distinction between essential and non-essential things.

Everything that Franz Marc ever did with painting, everything that he ever wrote, both before the Great War and then as a soldier in the Great War, was an attempt to affirm that there is a vast and mighty difference between the things that are essential and the things that are non-essential. "I cannot overcome," Marc wrote to Maria on December 2, 1915, "the insufficiencies and imperfections of life except by transposing the *meaning* of my life into the spiritual world, the world that is *independent* of the mortal body, that is, I must salvage it through abstraction. It is *not* really *future* life that I understand by the word 'spiritual'—in that respect you misunderstand me. . . . But by spiritual life I mean: to separate essential from non-essential things."

The Fate of the Animals

What it means to become spiritual, to become *geistig*, Franz Marc is trying to say, trying to tell his wife Maria, trying to tell us, what it means to enter existence on the plane of what is *geistig* is to live essentially in the here and now, not to look toward another realm, to look toward heaven or to the afterlife. Marc is thinking, among other things no doubt, of those passages in the Gospel stories where Jesus says to people that the Kingdom of Heaven is not a place off somewhere in the distance, but that the Kingdom of God, the Kingdom of Heaven is actually right here. Here it is. It is there, directly, within you.

What does it take to recognize the Kingdom of Heaven that is inside you? It takes, if nothing else, the willingness to purge what is non-essential, the willingness to let much that is non-essential drop away, to let it be burned away. "Every day," Marc tells his wife Maria later in that very same letter of December 2, 1915, "I throw more on the pile of the non-essential." "The beautiful thing," Marc continues, "in doing this is that the essential does not get smaller or narrower, but on the contrary more powerful and grand." This is why Marc can feel grateful for the Great War, even in all its horrors. The Great War is a kind of terrible vehicle for purification, for abstracting away all that is non-essential, for burning away all that is not *geistig* in its most essential sense. "The impossible situation," Franz Marc writes to Maria, meaning the very difficulty and the incredible tension and the extreme situations that

Painting that tries to reveal an inner truth

the war has placed Marc under, "into which the war has pushed my personality has greatly clarified my being."

Franz Marc's being was clarified by two things. His being was clarified first by the remarkable *annus mirabilis* that he underwent as an artist during the winter of 1910–11, and then, beginning in 1914, his being was clarified a second time by the extreme conditions in which he lived his life and then finally lost his life during the two years he spent as a soldier in the Great War. Because of this specific history, it is simply impossible now to disentangle Franz Marc the painter from Franz Marc the soldier of the First World War, the soldier who was killed by shrapnel during the infamous, almost-unnameable Battle of Verdun.

The act of painting and the act of being in the war became, for Franz Marc, experiences that were essentially fused together. They blurred into one another. They were outcomes of the same forces, the same history, the same causes, causes that are very difficult, at their deepest level, to access, causes that must be referenced with words like "fate" and with a word like *Schicksal*. To Franz Marc, the same destiny that gave him his *annus mirabilis* of the winter of 1910–11 was the same destiny that propelled him into World War I and to his eventual, personal fate during the Battle of Verdun, a fate that Franz Marc seems freely to have accepted, though not especially to have sought out, and to have reckoned that death is of no great importance in the face of the greater forces and destinies at play.

The Fate of the Animals

Going back then to the picture that Franz Marc painted in 1913, the now-famous painting that is titled *The Fate of the Animals*, it should be very clear that we are presented with a visual scene that is partially unseeable. What's truly to be seen in the painting taxes our descriptive language. We are looking, in a sense, at a picture that does not want to be looked at, does not want to be seen at all. Or, to put it another way, we are looking at a picture that does not want to be seen but does want to be *seen*. That's to say, when we look at *The Fate of the Animals*, we should be very aware that there are two kinds of seeing. There is the seeing that is just seeing—*mere* seeing, if you will—and there is the seeing that is *really* seeing, the seeing that is *geistig*.

If we are to take Franz Marc seriously as a man and as an artist—and we might as well endeavor to take him seriously if only for the reason that he took himself so seriously as an artist as to cast everything else in his life aside, to beggar himself, as it were, in his life leading up to the *annus mirabilis* of 1910–11, to alienate friends and family in his pursuit of what seemed to them a pointless goal for a not-especially talented man, a man who, nevertheless, relentlessly drove himself forward toward the point where, in fact, in the *annus mirabilis* of 1910–11, Franz Marc did break through to creating an art that conveys the same *geistig* qualities that he strove to produce in himself, that drove him to live life in a relentless and sometimes terrifying pursuit of what he understood to be *purity* and to be *truth*, and which finally placed Marc in the position of becoming a soldier

Painting that tries to reveal an inner truth

in World War I, a soldier who performed his soldierly duties admirably and with the dignity that, for him, was tied up with the purpose of a man going through life not wanting simply to see and to hear and to eat and to piss and to fuck and to die, but to do all of those things, yes, to do every one of those things, but to do so as one taken up into another realm of being, as it were, of having one's senses opened to the eternal that flitters at the edges of this pissing and eating and hearing, to open himself to the "utter thereness" that can strike a person as that person inhabits a body and is at the very same time aware and not aware of that inhabitation, lifted up and dropped back down at the very same time, you might say, seeing the unity of all being, of all living things while, at the very same time, being fully engaged with one's own specific and particular being, completely penetrated by love, as it were, completely overwhelmed by the unspeakable beauty of there being any Being at all and at the same time absolutely committed, as it were, to being the one specific being that one is, to participating in the grand cosmic tragicomedy as this one specific being that one is fated to be and being willing, at the very same time, to throw this specificity away, valuing it not at all and valuing it absolutely, valuing it absolutely for the very reason that one values it not at all and vice versa and wanting to show, in whatever way that one can, in whatever small and insufficient way, that this tremendous truth *is in fact true*, that the truth of valuing and throwing away one's precious subjectivity as the me-creature that one is is a truth that can be shared

The Fate of the Animals

and shown, that the eyes of one's fellow human being can be penetrated with this truth, which is beyond the physicality of vision but which tickles at its edges, and which can be hinted at and gestured toward and which, for Franz Marc, was the only true and honest reason for there to be any art at all, any art of any kind whatsoever, there is only this one reason for it to exist, that the point of art, its only point, is to awaken and communicate and to share between human beings the tremendous strangeness and the overwhelming oddness of actually being alive, actually and truly and really being alive right now, as it were, a realization that, when it is achieved, snaps you into the world perhaps for the first time ever, snaps you in with the unaccountably odd sensation, the deep realization, that one is both *in* the world but at the very same time not absolutely *of* the world, that one is both oneself, a firmly articulated bit of individualized there-stuff and at the same time that one is everything, that one is the totality and that each moment of one's specific-being is part and parcel of the total-being, and that one can actually live in this mode, experience life and oneself in this mode, experience and surrender to these overwhelming truths and realizations and have *one's eyes opened*, have them really and truly opened to what is really real, which is a truth and reality that is not beyond the real world, not outside of it, but is a truth that is hidden right there in plain sight, that is available for all to see should they allow themselves to see it, should they put away the fear and the smallness that trickles into the lives of all, that weighs them down and sinks

Painting that tries to reveal an inner truth

them into the world as if it means nothing, as if it isn't the strangest and most person-shattering fact simply to confront one's presence as a here-being-right-now and this bracing aspect of living as a person truly alive and awake gets covered and suppressed and dampened down by the fear of life, the natural unwillingness to see the utter strangeness of this and every moment right now, a fear that leads, inevitably, into the suppression of life and the forgetting of life and the regularization of life and, finally, to the forgetting of the fact that one has even forgotten, to the meanness and the smallness and the cutting-up and the parceling-out of our day-to-day experience so that the magnitude, the sheer experiential magnitude of our actually being alive and actually being about-to-die at every moment is buffered so that we cover ourselves and others in a suppressing and muffled layer of everydayness that becomes a protective coating, as it were, by which we suppress the power and the magnitude of the real truth of our being-here-right-now, and it is the job of art, as Franz Marc saw it with every fiber of his being, it is the job of art to rip away the protective coating, to penetrate the layers of forgetting and to bring us back, kicking and screaming if need be, to the real reality of being this creature who is not only a mass of flesh but who is a *geistig* presence, a luminous cutting-through-space-and-time to open up this spot, right here and now, and to make this spot of what is otherwise only a being-in-*potentia*, as it were, to make this spot of being-in-*potentia* into being-this, and to paint that transformation, to paint the full truth of

The Fate of the Animals

really seeing, of really and truly *having one's eyes open*, this was the entire meaning and purpose of Franz Marc's life and of his art, or, at least, so it seemed to him.

We can, if nothing else, take him seriously in this.

12. We bring up Edgar Degas, for a reason that probably has to do with horses.

THE FATE OF THE ANIMALS IS, THEN, A painting that we'll have to look at very differently than we might look at, say, a Degas painting. Not that there aren't levels of meaning, levels of seeing in a Degas. There most certainly are. But Degas was not trying to penetrate the visual field in the way that Franz Marc was trying to penetrate the visual field. Degas was, we might say, showing us his way of looking at the world with great subtlety and with a certain refinement. He was showing us how to look, showing us how to perceive with the refined detachment of a cultivated man. He was guiding us with great subtlety toward certain attitudes, certain ways of feeling. Edgar Degas once said, "Art is not what you see, but what you make others see." Degas, as a painter, was therefore a kind of teacher. He is a guide, an excellent guide, into the realm of seeing. This realm, with Degas as our guide, can be a realm of great sensibility and great refinement.

The idea, however, that seeing itself is a sort of dead end, that the true task of painting is to take us

beyond the act of seeing with our eyes and into the realm of seeing with our *Geist*, with our spiritual being, this thought would have been too much for Degas. This would have entered into the territory of mysticism and, for Degas, mysticism was mystification. Degas was the very opposite of a mystic in that he was a bourgeois of the highest order, which sounds like an insult but is by no means an insult. Degas himself would have understood and appreciated the compliment. To be a bourgeois of the highest order, to live out the implications and the modes of being that are bourgeois, requires a kind of deep honesty. To take on the prejudices and the assumptions of the bourgeois way of seeing, to take them on even as a burden and an obligation, this is a noble endeavor of sorts, an endeavor to which one must sacrifice many other aspects of being human. One must surrender one's being to the totality of being bourgeois, which is, essentially, the task that Degas took on for himself.

I bring up Degas for the reason that Degas was quite fond of horses and made quite a lot of paintings of horses. Degas had an understanding of animals in general, but especially toward the horse. This, if nothing else, draws Edgar Degas and Franz Marc together as painters. But the beast that Degas painted and the beast that Marc painted have almost nothing to do with one another beyond biological identity. Degas's horses are fundamentally restrained creatures. They are creatures of civilization. Rarely does one see a horse in Degas's paintings that is not fitted with a saddle and a bridle

and other trappings of its domesticated nature. In his drawings, we should note, Degas was known sometimes to treat the horse in the horse's wild and unbridled state. But this was by way of studying the anatomy and the physicality of the horse precisely for the purpose, the sole purpose of making paintings that showed horses being ridden by human beings at the track, or in games of polo, or fitted to carriages and buggies of various kinds.

Edgar Degas was not a fool. He was, as mentioned above, a highly sensitive human being. He realized that the painterly interest of the horse consisted in the visual tension, as it were, between this beast of great natural power and strength and the "harnessing," literally and figuratively, of this strength and power for the purposes of human refinement. The dynamism of Degas's horse paintings—and they do contain a quite marked dynamism—comes from the fact that Degas had great respect for the sheer power, the naked animality of the horse. He understood the ancient character of the horse. He understood the primal force that was packed into the bones and sinews and muscles of the horse. He understood that there was something absurd and at the same time tragic about the harnessing of this prehistoric beast for the purposes of civilizational refinement. Degas got the joke, if we can call it that.

To some degree, we can say that the horse paintings of Edgar Degas are studies in the ridiculousness of late-nineteenth century European civilization. The fine bourgeois families are all dressed up in the regalia of

the age. The horses are all dressed up in the regalia of the age. Even the horses! What an absurdity, to dress up even a horse and to make this horse a player in your bourgeois playacting! And Degas subtly directs our eye at all this regalia such that it almost falls apart completely, it almost becomes a mockery of what we're being shown. Look at these funny creatures dressed up and holding themselves so, we want to say. Look at the hairless monkeys and the quadrupedal prehistoric beasts dressed up in their finery. This thing can't hold. This game will not last.

Except that with Degas, it can last. It will hold. Degas always brings us to the tension-point of possible ridiculousness and then freezes it right there. He doesn't let the thing collapse of its own weight. He holds it up. Degas spent a lifetime pointing out the absurdities of nineteenth century European civilization just so that, in the last instance, he could hold them up. In the end, for all that is laughable, for all that teeters on the brink of the absurd, this civilizational structure, Degas wants to say, is absolute. It is necessary. It has a strength that holds it all together. It must hold, and it will hold. Degas's canvases never break down into incoherence. They are strong. A greater force is always in control, holding the men to their beasts, holding the beasts within the confines of their role, holding the scene within a balance of form and shape and structure that never goes too far astray. Degas shows us the strength of the absurd European civilization in its last days of holding together, before it came apart, before it pulled

itself apart at the seams and exploded in the fires and tumult of the war that was later to take the life of Franz Marc.

Amazingly, it was Edgar Degas, the man of the nineteenth century, who would outlive Franz Marc, the man of the early twentieth century, if just by a couple of years. Both men would die during the battles of World War I, Marc in battle, Degas wandering the streets of Paris, blind and confused, disoriented by the collapse of the very structures he had assured us, in painting after painting, were essentially permanent and immovable.

Degas tried with all his might to prove that his civilization could hold and that its tensions could hold, and he did so, instinctively, by tackling the problem of the horse countless times upon the canvas. In one of Degas's lovelier horse paintings (*Horses in a Meadow* from 1871), we see, in the foreground, two horses standing in a meadow. The darker horse faces sideways and is resting his head across the back of a white horse, which we see from the rear end. This is something you'll actually see horses do in the field, if you observe them for long enough. You'll see cows in the field do this as well. Seeing such a thing is a reminder of the ways that animals can be bound together fully of their own accord, according to their own decisions, as it were, and without the direct interference of human beings. There is a love, you might say, that holds animals together in their natural setting just as there is a natural competition, a natural striving, and also, of course, a natural killing that occurs in the animal world. Sometimes we get a glimpse

of the gentler side of these forces among the animals. Degas's picture is the recording of one such glimpse. It is clear that Degas himself was moved by what he saw, was touched by the simple gesture by which the one dark horse rested his head and neck on the back of the other white horse. The horses trust one another and accept the situation of mutual physical contact. This is nature showing us a peek into the structure of care that can sometimes be revealed, even in the wild. The wild is not all Darwinian struggles for survival, is it? The wild is also these striking and oddly unaccountable moments of care by which one creature will acknowledge and act upon its dependency on another animal. Care will come to the fore. This happens. Degas saw it happening and created a picture to memorialize this unexpected but moving instance of creaturely care.

But Degas cannot let it go at that. Something in him resists the idea that this care could be fully independent, that it could exist entirely outside the network and framework of human activity, human meaning, civilizational structure. Franz Marc, by contrast, portrayed groups of horses in physical contact with one another. But these horses have no need of human beings, of human structures, of civilization. Their acts of physical communion are internal to the horse-world they inhabit. This world is sufficient unto itself.

Even in his portrayal of the two horses in the meadow engaged in an act of mutual care, even in that internal-horse-world scenario, Degas could not resist

We bring up Edgar Degas

including signs and symbols of the otherwise human world that those horses inhabit. Degas shows us—by means of a little house and farm structure in the middle ground of the painting, along with a number of steamer boats that are docked at the far side of the river, also in the middle ground—that the meadow the horses inhabit is not their own meadow. This is a human meadow, bounded by human concerns, human structures. The painting, therefore, goes so far even as to suggest, though subtly, that the act of care between the two horses is a function of their being held within the civilizational structures of human beings. These horses are (it is made clear in the painting) farm animals and therefore, in an important way, domesticated. The painting cannot say so explicitly, but the question is raised as to whether it would even be possible for two horses to exhibit such care for one another were they not domesticated.

That's to say, even though Degas's painting is but a simple picture of two animals sharing a touching moment, it is actually quite a huge statement about what is possible and what is not possible for animals. Do animals need us to be truly what they are? Degas's argument is roughly the following: the possibility of care, whether shared between men or shared between horses, the possibility of care as such is not given to us right away, right out of nature. No. Care is an accomplishment. Degas shows us with his slightly sentimental picture that care is something that only comes along with the culturing process, a process that

is headed-up, as it were, by human beings and only by human beings.

The idea of the wild as such, of the world of animals untouched by the culturing structures of human beings, is implicitly repugnant to Edgar Degas. He has no place for such a world in the pictures he creates. In this, you might call Degas a Herculean painter, Herculean in the ancient sense that Hercules was a great tamer. Hercules was the man-God who went into the wild, was half-wild himself but whose connection to the wild was in the service of the cultivated. His job was to bring the wildness to its knees. His job was to make culture out of what existed at the furthest boundaries of culture. The violence of Hercules is the violence of the cultivator, the tamer. Violence is probably the last thing that anyone would normally associate with the canvases of Edgar Degas. Still, it is there. Hidden, it is there. Degas, the most Herculean of nineteenth century painters, was ever hinting at the implied violence undergirding the civilizational structures that bind human beings together with human beings, and that bind animal to animal, and the wild to the cultivated.

13. We continue burrowing into the horse paintings of Degas, his love of bourgeois civilization, and his deep feeling for the absurdity and necessity of that civilization.

PROBABLY THE FUNNIEST OF ALL EDGAR Degas paintings is thus a painting he made around 1862 that shows a single horse, as well as a little dog, inside a stable. The painting shows the front half of a brown horse, from the side. The little dog sits below the head of the horse and faces us. The dog is an idiot and gazes lovingly, if pathetically, out at the viewer of the painting, the human being who cannot be in the picture, but does not need to be. The painting is, in that sense, completed by whatever anonymous viewer steps in front of it. The silly dog is waiting, perpetually, for some human being to step up and give it something upon which to direct its slavish gaze. This is the type of dog, by the way, that has been bred by humans over many centuries to exhibit exactly the sort of total human dependence that only dogs can achieve. No other sort of animal has ever been able to go quite as far as the dog in being able to direct its being, its entire purpose for

being, completely toward the human. Degas captures this quite well in the posture and the gaze of the dog in this painting.

The posture of the dog, the utter being-toward-human of the dog is contrasted, ever so pointedly, by the situation of the horse. The horse is not slavishly directed toward the viewer of the painting. But what is the direction of a horse? The strange morphology of a horse head is an almost arrow-like pointing toward what is to come. The horse is a profoundly futural creature, you might say. The horse is directed to the wind, to the possibility that, at any moment, the gallop may happen. The horse is shaped to take off.

But the eyes. The eyes are situated sideways. One suspects a horse must have two brains, one for each eye. Of course, the head of the horse is just so tapered that the eyes can come together for a look straight ahead. The horse has one way of being: a laser-like focus on what is before it. But the horse is also a sideways creature. Does the horse experience the world in a futural directionality but then shift to another sort of being and seeing that is fundamentally "to the side"? Coming up to the side of a horse, one is somehow aware that the horse has you in its gaze, but that this is not the complete gaze. There is another gaze. The horse can never be fully smitten by only one thing in a way that the dog can. Degas has captured this morphological/epistemological oddity perfectly in his picture. The dog swoons stupidly in its complete attention to the human viewer. The horse is

The horse paintings of Degas

aware of the viewer, but also aware of what is happening on the other side.

There is another strange thing about this painting. The horse is wearing some sort of gear. It is a white bridle, without the reins attached. Just the bridle. One would have to be an expert in nineteenth century horse matters to know exactly what sort of bridle this is or why the horse is wearing it in the stable. The technical details, anyway, are not so important. The point is that this horse seems to be placed in an almost clinical situation by this bridle. The horse seems to be wearing something that a person in a madhouse or corrective institution might be wearing. It is the whiteness of the bridle that gives this impression, and the way that the bridle straps hug the head of the horse almost like bandages. Perhaps this is a training bridle, something meant to ease the horse into familiarity with wearing a bridle, which, it should be noted, must be an intensely unpleasant and uncomfortable thing for a horse to wear. The bridle is, after all, a contraption by which a bit is inserted into the mouth of the horse, and a bit is nothing but a piece of metal stuck into the mouth of a horse. Horses, it just so happens, have an area of mouth between the incisors and the molars where there are no teeth. Humans, with the sort of fiendish cleverness for which we are known, realized that if you stick a metal bar in there and then connect that metal bar to reins, you can gain almost complete control of a horse and the movements of that horse. You can yank this way and that on the bridle, and the horse will have to obey you

for the simple reason that it is quite painful, no doubt, to have a metal bar yanking sharply this way and that on the soft part of your gums. People talk about how much they love horses and love riding horses. This is no doubt true. But the process of this riding and taming of the horse is a process of continual violence. Real violence in the situation in which the horse is yanked this way and that, and implied violence in the sense that any horse with a bridle on has a bit in its mouth that carries a threat of unpleasant pressure on the soft and hurty parts of the inside of its mouth.

So, looking again at Degas's painting of the horse and the dog, we are looking at two animals who are really two examples, two situations in which the sordid spectacle of animal/human relations are laid bare before us. The dog has been brainwashed, as it were. The dog has become a drooling idiot man-starer waiting patiently and slavishly for some human being, any human being, to meet its gaze and to give it some sign, some indication of what it is supposed to be doing. The dog has been robbed of any possibility of living for-itself. The dog lives only for-another. In this case, it lives for-us, for whoever it is that steps before the painting as a viewer thereby becomes the object of the infinite, slavish gaze of this stupid dog.

The horse, by contrast, maintains some small scrap of its dignity in that the one-eyed sideways gaze of the horse means it can always counteract the power of the human with the morphological power of its permanently free other eye. The eye on the other side can always look

elsewhere. The horse, in some part of its unfathomable brain, can always pay attention to something else. Well, not always. Humans, in our indomitable capacity for premeditated cruelty, also thereby invented the horse blinder. And there are, in fact, as we would expect, several Degas paintings that show horses wearing some form of blinder.

The blinder is the mechanism by which human beings expressed our rage at the morphological freedom of the horse, the capacity granted by the wide spacing of the eyes on each side of the head that allows the horse to shift from the forward look to the sideways look whenever it pleases. The gaze of the horse is difficult to hold and capture for that reason. In rage, the human creature realized that the bit and the bridle were not enough. In rage and frustration at the forever-wandering sideways glance of the horse, humans came up with the simple but devastating answer of the blinder. Your strange head morphology is your secret freedom, is it? Well, try this then. Try some of your sideways glancing now, beast. You are defeated.

Still, a horse cannot be forever in blinders. Even a horse in a stable, even a horse fully integrated into all the civilizational structures is going to have periods where it is less strapped-in, less harnessed and blindered and constrained. This painting by Degas of the horse and the dog in the stable shows one such moment. The horse has a bridle on, but nothing else. From the perspective of this painting, the other eye of the horse is an eye that we shall never know, never confront, never

understand. So, for this very reason, this is a tense painting by Degas, even as it seems so calm. The dog is no threat; the dog will sit there forever waiting for the gaze to complete it. But the horse reminds us that the work, the always and forever sort of struggle that is the process by which we make the world submit to its civilizational structures, this is an ongoing process, never complete as such, never free of the threat that it could unravel, jump its bonds, unspool and tumble uncontrollably in the other direction. Civilization holds the world, but it holds the world in a tense embrace, and the bonds of that embrace are straining and buckling at a thousand points, a million, an uncountable number of points, the whole heaving and throbbing mass in constant motion and transformation even as the mass conforms to the structure that is civilization and even as this civilizational structure grows more powerful, seemingly year by year. It grows more powerful but also grows more brittle.

Just look at another one of Degas's horse paintings. This one is called *Horses in a Landscape* and was painted around 1860. The painting is oil on canvas but done in an almost sketchy style. It is argued by some that this is not a work by Degas at all. That's to say, the attribution of the painting is under some contestation. This is at least partly because the work does not seem to fit in with Degas's typical style, even the style of a young Degas who, in 1860, or thereabouts, was still only in his mid-20s.

The horse paintings of Degas

The painting shows a pair of horses in a rougher and wilder setting than that within which Degas was more typically given to painting horses. The later Degas almost always painted horses in the setting of a horse race or polo match, or around carriages and wagons, or, in the aforementioned painting, in a cultivated field or meadow, or in the direct context of a farm. In *Horses in a Landscape*, however, Degas, if it was Degas who painted the picture, painted two horses in a scene that is wilder and further to the margins of civilization than was typical for Degas.

There are two horses in the painting. One is gray and is sitting down in the grass and weeds, resting somewhat uncomfortably, it seems, on his left haunches. The other horse, brown with white markings on his face and hooves, is standing up and, though faced away from us bodily, turns his head back toward us. It is this turning of the head that gains our attention. There's a tinge of struggle in that backward turning of the head, as if the horse is straining at something. That's when we notice that the horse is tethered to the ground by some kind of rope. We see also that the gray horse is saddled, and that in the extreme foreground of the picture a murky human figure rests in the grass.

At first glance the painting is pastoral, filled with much calm and repose. At second glance, this repose is unsettled by the tension between the horses in their wildness and the horses domesticated. The setting helps this tension along. We aren't in a place of full civilization. We are in a place of partial civilization. Plant growth has

become unruly. There is a structure just in front of the two horses. It is the wall of a building, and there is an opening in the wall. The opening must once have been a doorway or a window. But not anymore. This is a ruin. This is a human structure that has fallen out of use and is being reclaimed by nature, reclaimed by the wild.

The brown horse turning his face toward us is responding, we might say, to the slackening hold of civilization in the form of the ruin he stands before and the unruly vegetation all around him. The horse is responding, ever so slightly, to the wildness that surrounds. He tugs lightly at his fetters, testing the waters, as it were. Will a little tugging and pulling cause the reins and the bridle to come off altogether? This is a dangerous place. A dangerous line between civilization and its other is to be found here.

Degas understood that civilization was a fine line. He understood that civilization exists because wildness exists and vice versa. He understood that there was a gray and hazy boundary between the two. He understood that, in some deep sense, civilization is intolerable. He also understood that civilization is necessary. He thus created an art that expresses, often with great subtlety, the relationship between what is intolerable and what is necessary, that what is necessary can also be, down into the very bones, something experienced as intolerable.

Take the famous ballerina pictures. These are pictures that show us, like the horse pictures, creatures in the act of being tamed and of taming themselves. Civilization, as Degas understood it, looking deeply into

its inner struggles, is a tremendous amount of work. The contortions of Degas's ballerinas, for instance, are the contortions of creatures forcing themselves bodily into the constraints of civilization. Civilization, for Degas, was a physical matter; it could be seen physically all around us. The strange angles and the odd viewpoints of Degas' paintings of ballerinas are the work of looking, the work of really seeing the ways that civilization plays out physically, right in front of us, all the time.

Edgar Degas's famous *Two Ballet Dancers* from 1879 is a painting, really, of two workhorses. The two dancers sit with their tutus puffed somewhat ridiculously around them as they stretch and prepare for the performance to come. They pull and prod at their own bodies, which must be manipulated in such a way as to perform the civilizational tasks required of them. They are no different from the horses who get hitched up to a carriage or take on a rider in order to perform in a horse race.

The specific subtle brilliance of Edgar Degas was to show us the physical absurdities, as it were, of the civilizational process on creaturely bodies while, at the same time, endorsing this absurdity. Degas's painting career is a lengthy discourse on a single subject: beauty. Beauty, true beauty, for Degas, is only possible given this absurdity. True beauty comes of the physical absurdity enacted on bodies in the service of civilization. This is what Degas painted, drew, and sometimes sculpted over and over again.

The Fate of the Animals

It is perhaps a monstrous idea that this is what beauty is. It is, maybe, a monstrous and horrifying vision that he shows us. Of course, it may also thereby be that much more true. That is the honesty and the truth-seeing to be witnessed on the canvases of Edgar Degas. Here is the awkward and tortuous beauty that we have given to ourselves, says Degas. Here is what we have done to ourselves and to the beasts and to the landscapes that surround us. Here is what we have done, and we'd best look at it with the cold eye of truth. And if we are to love it, we are to love it and to submit to its cruelty, for its beauty is in the harsh necessity, the overwhelming, inescapable logical force of its cruelty. And this cold cruelty is the only beauty we can know, or have, or be.

Even Degas's pictures of women bathing ought to be seen in this light. They are pictures that show the drama of beauty within the civilizational constraints of late nineteenth century Europe. I say the drama of beauty. Look, for instance, at the pastel and charcoal drawing *Bather Stepping into a Tub* from around 1890. This is a ridiculous picture. Even those who stupidly fawn at Degas pictures in complete incomprehension are forced to recognize that there is something distinctly awkward in this picture and in other bathing pictures Degas created throughout his career. That word "awkward" is often used. It is widely acknowledged that Degas captured women bathing in such a way as to bring out the awkwardness of the act. In *Bather Stepping into a Tub*, we see the woman from behind. She places her left hand

The horse paintings of Degas

tentatively on the rim of the tub and is in the process of maneuvering the rest of her body into the bathing tub. As we all know, this can be a tricky procedure. There is the possibility of slipping and falling. And once you fall in a bathtub, the pitiless logic of physics takes over. You are at the mercy of the sliding and the upending and the topsy-turvy limbs akimbo disaster that goes along with falling inside a structure that isn't designed to hold you up, but to cradle your form when you are down.

Commentators will characterize this drawing, and other works like it, as simultaneously "sensual" or even "erotic." This is patently absurd. It is a mark of the confusion that often goes along with looking at pictures by Degas, whose soft pastels and gentle color palette was always at the service of something pitiless. If you don't understand the pitiless nature of Degas's art, you are never going to be able to look at the pictures truly. Put away your previous notions of Degas. Look, instead, at what is actually in front of you, which is something hard and startling and discomfiting in the relentlessness of its truth-telling. The paintings of Degas ask us to look deeper and to see the violence of the civilizational process. But that isn't all. It is the perverse genius of Degas to force us to look into the latent Herculean violence of the civilizational process and then, at the moment we see the horror, demand that we love it. He demands that we encounter the horrific physical and emotional contortions that civilization forces down the throats, as it were, of mere animals, and then he demands that we worship at the feet of these horrors.

The Fate of the Animals

Civilization is beautiful to Edgar Degas because of its almost impossible difficulties. The difficulty of washing the human body so that it may slide back into its corsets and ties and bonding. The difficulty of getting the young girl's body into a tutu and then to bend the legs and back and arms in every way unnatural. The women must submit, the dogs must submit, the horses must submit, and then, finally, the painter and viewer must submit too. Precisely to turn nature into what it must be under the bonds of civilization but never, oh no, never to eradicate it completely. What we see in the lumbering women's bodies getting into their baths is that the body is always a natural, animal, fleshy thing. And this fleshy thing must always writhe and buck and almost, but not quite, revolt. There is no civilization without that tension. At least, that is how Degas saw it, and he looked as deeply as anyone else. There is no civilization without this wonderful and relentless torture.

14. We finally let Edgar Degas go, his confrontation with human civilization having exhausted us, and we turn back to Franz Marc, who developed a form of painting that takes over from the exhaustion of Edgar Degas.

FRANZ MARC, BORN A GENERATION OR so after Edgar Degas, found himself unable to paint in the manner of Degas. Degas's civilizational proposition no longer made sense to Marc. The tension point had been pushed too far. For Franz Marc, the absurdity, the physical absurdity of civilization and what it does to creatures was no longer producing beauty. It was producing ugliness. The antidote to this situation might therefore seem obvious. Throw off the yoke. Throw off the rein and the bridle and the blinders. Go back to the wild, to the free, to the unencumbered. Franz Marc's art gets close to saying this sometimes. Franz Marc himself came close to thinking this on many occasions. His fascination with the war that was going to destroy his own life was, as we have seen in letter after letter to Maria, a fascination born of the hope that

World War I, for all its horror and degradation, was also going to potentially destroy the structures of ugliness that had crept into the very heart, as Marc saw it, of European civilization.

It would have been easy for Franz Marc to have become an artist of the reaction. And he was, in a sense, always an artist of the reaction, a reactionary artist, an artist reacting to the terrible bind in which the civilization of his time had found itself. He could, therefore, have looked to the wild and become an advocate of the wild, the primitive, everything that is opposite to the civilization that was tearing itself to shreds, right before his eyes and before the eyes of an aging Degas too.

Marc certainly saw the power of the wild and of the primitive. He was interested in tapping into the powers that are there, latent in every work of art that predates the modern world. The volume of writings and art and reproductions that Marc produced with Kandinsky, the almanac of the *Blue Rider*, is a testimony to just these latent powers and to all the forces that were bubbling to the surface as European civilization was destroying itself. But Franz Marc had no interest in canceling the modern and returning to something pure. He was looking in the other direction. Something prevented him from looking backward. He wasn't the typical reactionary in this sense. He didn't see the crisis as a chance to go back, but as an opportunity for an unexpected leap forward. If he was a reactionary, then his art was the product of the unexpected reaction, the reaction that accepts the

civilizational bet and then doubles down on that very bet.

So Franz Marc was never an advocate for the return to the wild, for a reintroduction of the primal as such. Edgar Degas was a man of the present, and D.H. Lawrence was a man against the present. But Franz Marc was a man of the future. Franz Marc looked to the future with hope. We should not forget this otherwise surprising fact. Knowing as we do the catastrophe that was World War I and the fact that World War I was to lead, in the inexorable historical progression of one catastrophe to another, to the even greater catastrophe of World War II—knowing this, the idea that Franz Marc could see the full horror of the situation before him, give his life to that horror, and still, to his dying day, be a man essentially of hope is a difficult thing to fathom. But fathom it we must.

Indeed, Franz Marc was so focused on the future, so alive with the possibility of the future, that he worried this aspect of his art would seem downright utopian. In a letter to Maria written from Mühlhausen on December 22, 1914, Marc expressed this fear. "I am afraid that people will declare my thoughts to be beautiful but too utopian—it is the objection I want to counter with the greatest passion." What Marc means here is not that he fears his hopes for the future are too optimistic. Far from it. Marc held amazingly optimistic hopes for the future, and those hopes were never abandoned even up until, we must presume, the very last moment. He thought until his very dying day on the battlefield of

Verdun that the possibilities for a kind of *geistig* leap, a spiritual leap forward, were not only high, but that such a leap was imminent and was to be seen just upon the horizon.

Marc's fear was not about his own hopes, but about the possibility for other people to understand those hopes. He feared that people would think his beautiful thoughts too utopian because they saw no way for those thoughts to be realized in the actual world of their own time. Marc feared that the label "utopian" would allow people to ignore his hopes, to push them away. He feared that people would misunderstand his vision, thinking that he was expressing thoughts about a far distant future. But Marc did not see the future that way. He saw the future as a kind of right-now immediacy.

Marc felt, deeply felt, that his beautiful thoughts were absolutely realizable, that they were not utopian for the very reason that they were utterly concrete. Franz Marc did not see himself as a utopian but as a cold-eyed realist. This is the startling twist to Marc's "futurism." In the lens of his cold-eyed realism, he thought he saw the world sparkling in spiritual ferment all around him. He saw Spirit with the blunt realism that is normally the reserve of the prophet. "Look," he was saying to us, "it is real. It is right there in front of you." Marc was a futurist because he thought the reality of spiritual life was so close to the surface that it might bubble forth, it might erupt tomorrow, or perhaps later this afternoon. Right now.

We finally let Edgar Degas go

In the same letter from Mühlhausen, Marc also wrote, "I can try only in paintings to realize my concept of the future, but I hope with great fervor that there will be men who can realize it in literature, philosophy, and behavior, at least for a small circle of people; this small circle would prove more than if the clumsy masses would start moving." This is vanguardism in the extreme, we might say. Such vanguardism was not unusual at the time and in the milieu in which Franz Marc found himself, the milieu of early twentieth century artistic practice. Marc reveals in this same letter that he sees his paintings as "realizing his concept of the future." But it is not immediately obvious to us how paintings of red cows and blue horses "realize the future." What sort of realization is this, and how does it relate to what is yet to come?

Hearing this idea about a painting "realizing the future," we've got to think immediately again about Marc's famous painting, *The Fate of the Animals*. Marc was himself, as we know, startled by the degree to which that painting seemed to have anticipated aspects of the World War, a war that had not yet broken out when the painting was painted. It was a painting that looked ahead. But the comment Franz Marc makes in his letter to Maria is not primarily about foreseeing the future or about acts of prediction. Marc is not saying that paintings have an ability to predict the future. He is saying that paintings, his paintings in particular, are acts of future-realization in themselves. He is saying that we should look at a painting like *The Fate of the Animals* as,

in a sense, the real future existing here in the present. Literally, it realizes the future, it makes it real.

15. What, exactly, is a prophet? What does it really mean to exist in a prophetic mode, to bring prophecy, to see the future, or the past, or the present? What is a prophetic painting?

S O WE CAN SAY THAT MARC SAW HIS paintings as future-revealers. They revealed a sense of the future in the present. Not by foretelling what was going to happen—they were not future-foretellers. Franz Marc did not see himself as a soothsayer or as a sibyl or an oracle. Though you might say that Marc envisioned painting as existing in oracular space, if we are willing to understand that term in the proper ancient sense. The ancient oracles, the ones at Delphi and other places throughout the Hellenic world, were not places, primarily, for having your fortune told, as we tend to view it now.

The whole situation at Delphi is often described and approached as if it were some sort of giant parlor trick. Money and riches were given to the Oracle, and the Oracle made a prediction vague enough to be interpreted in whatever way the customer wanted.

This is the scam of fortune-telling as it has existed throughout the centuries. Surely there was some aspect of this game happening at Delphi. There were politics involved. There was money and power involved.

But there was also something else happening at Delphi. Or perhaps we should say that the phenomenon that now goes under the name Oracle at Delphi hides within itself some truth of experience that we can only vaguely understand. The Oracle was not a fortune cookie. The Oracle, in its essence, was a place of real reality. It was a place where the ultimate reality underlying reality had a chance to break through the veil of appearance. There was, in fact, or so it is said, a kind of crack in the earth at the spot where the Oracle at Delphi was to be found. Some say that it was from within this crack in the earth that some kind of deep vapors, gasses from deep within the belly of the earth would seep out. These vapors would be inhaled by the sibyl, who would then enter a kind of frenzy, a divine state of speaking. This state of speaking was barely to be understood. It was speaking at the very limit of speaking, words that dive so deeply into the heart of meaning that the meaning becomes obscure.

The cracked earth and the place of the sibyl was thus a place where the absolute could show itself as the absolute. Of course, this is impossible. For the absolute to show itself is for the absolute already to limit itself, to come into appearance, and therefore not to be the absolute. The absolute can only show itself by not showing itself. So the Oracle is a place of

What, exactly, is a prophet?

internal contradictions. Heraclitus says that the Lord, whose Oracle is at Delphi, neither reveals nor conceals but gives a sign. This is Heraclitus's way of expressing that deep contradiction. The Oracle can only express itself by already veiling what it expresses. The deepest truths can only be expressed by being simultaneously concealed.

That's the best that the Oracle can do. Or we should say that the places, the occasions where the noumenal world penetrates farthest into the phenomenal world are the places of greatest tension, of internal contradiction, even of a kind of craziness. The sibyl must hover at the very edge of madness, of incomprehensibility, for the very reason that she is standing, literally, at the place where a fuzzy impossibility is making itself visible, if only for a moment, a glimpse, a shudder in the fabric of being as the un-manifestable and the manifest overlap ever so slightly, leaping from the mouth of the sibyl as she inhales the vapors emanating from the crack in the earth, the crack in the world, the splitting of the realms, the breaking through of that which is beyond every determination into the realm of that which is determined. And so the sibyl cries out and writhes and spits words that seem to come from the outer cusp of what language can say, utters cries and groans that are the core of the physicality of language and then gives forth sayings that are, by nature, so meaningful that they can mean everything and nothing, that are beyond time and beyond space and beyond every phenomenon and appearance.

The Fate of the Animals

Then the humans who hear this utterance at the very limit of comprehensibility try to make sense of it. They try to unlock the puzzle. Inevitably, it turns into a silly game. What did the Oracle really mean? What's going to happen in the war? What's my fate? Natural questions in the world of everyday life. But ultimately stupid, pointless questions in light of what the sibyl has tried to reveal. The sign of the sibyl, the sign that is actually beyond revealing and beyond concealing as well, this sign has no real place in the world. Its meaning cannot be "translated." But we, in our stupidity—an inevitable stupidity, a forgivable stupidity, a stupidity that comes from being creatures of time and of needs and of desires—translate the untranslatable and try to make use of it. And so the sign of the sibyl fades back into the infinite night, into the abyss of meaning and back into the crack of the world.

So if I can convince you of one thing and one thing only, it would be that we ought to look at Franz Marc's *The Fate of the Animals* not as we would look at other sorts of paintings, but that we should receive the painting as one might receive a saying from the Oracle at Delphi. We should receive the painting through our eyes in the same way that we would receive the saying of the sibyl through our ears.

This begs the question of whether our eyes are truly open and whether our ears are truly open. *The Fate of the Animals* is, in fact, a painting that demands something of us. In truth, we ought to approach Marc's painting with a certain amount of trembling and fear.

What, exactly, is a prophet?

We ought to approach it knowing that it is a fearsome painting. The ancient Hebrews talked about the fear of God. This sounds hectoring and scoldy to the modern mind. But it was not a small thing to the ancients, not a matter primarily of standing before a judge or being worried that a parent might scold us. The true cause of the fear before God, the trembling before the absolute, was the natural fear of any particularity in the face of a totality that is, by definition, its utter dissolution. The fear of God is the fear of a glimpse into the absolute that will eventually take everyone and everything. The fear of God is the fear of the wisp of grass standing suddenly alone in the field as the great wind sweeps through, the great scythe, the reaper cutting down the ripe corn, stalks falling before the great blade as if they never existed.

The fear of God is the fear of the individual that does not want to let go, does not want to be reminded that the boundaries of that individuality are, in essence, nothing at all. And that those boundaries will be washed away. And that the God of life is the God of death.

With these thoughts in mind, it is funny to stand before Franz Marc's *The Fate of the Animals* today. The painting is to be found in the city of Basel in Switzerland. Today Basel is a city dedicated to the quiet accumulation of wealth and to the realization of a European comfortableness that Franz Marc equated, in his letters to his wife Maria, with a kind of death, a death more horrible than physical annihilation, a death of the spirit. What Franz Marc desperately hoped for, to be

perfectly honest, was that the Great War would destroy everything in the European soul that led, in actual fact, in actual history, to the Basel of today, to the rich and content and self-satisfied cities of Switzerland in the early twenty-first century. Franz Marc was disgusted by that sort of wealth and comfort, and he wanted it all to be destroyed. We can't sugarcoat this thought or turn away from it. Franz Marc loved and admired the World War, a war that killed millions and destroyed his own civilization, the civilization of Marc and of Edgar Degas forever, never to return, the war that was to kill Franz Marc himself. This terrible war was a war Franz Marc wanted, and he wanted it to destroy, as much as possible, the safety and contentment that had brought that same civilization into the very crisis that now threatened to destroy it.

Franz Marc welcomed this contradiction and felt that the destruction of the Great War was something his society greatly deserved. He thought that the terrible bloodshed of the World War was richly deserved. It was, to him, a form of justice. He feared that all the suffering of the World War would be for nothing unless that suffering helped to wake people up to the true nature of their humanity and the need to build a different kind of civilization, one in which spiritual awakeness would be more important than comfort, in which spiritual struggle would be valued more than material accumulation. *The Fate of the Animals* is a visual document of these hopes.

Today the painting hangs on a wall of the Kunstmuseum of Basel, Switzerland. There are thousands

What, exactly, is a prophet?

of works of art in the Kunstmuseum. Affluent Europeans stroll along the halls of the museum day after day gazing at all the art and, later, enjoying beverages and pastries in the cafes of the museum, and then walking out into the lovely cobblestoned streets of the old city of Basel. *The Fate of the Animals* is not, in the lovely contemporary city of Basel, experienced as a work of fear and trembling. People do not stand before *The Fate of the Animals* as one would stand before the Burning Bush. People do not avert their eyes. People do not hesitate to look upon the work. They don't hear the murmuring of the sibyl when they contemplate the painting.

Generally, they do not contemplate the painting at all. How could they? They do not live in a world in which the painting could be received as anything but another pretty thing on a wall. They see the painting, as the Hebrew prophets would say, without actually seeing the painting. *The Fate of the Animals* was made to live in a world very different from the world in which it actually lives. The painting is today, therefore, both here and not here. The painting is a parenthesis. It is a slight interruption, nothing more, of the world that exists all around it. It is a tiny crack in the surface of the earth in Basel, Switzerland. A crack that is barely to be noticed. No steam or vapors issue from this crack, as those vapors once issued from the crack at Delphi. Nothing happens, nothing happens at all in the room at the Kunstmuseum in Basel where *The Fate of the Animals* hangs on the wall. It is a painting about fate whose own fate is to have no fate at all. At least for now.

The Fate of the Animals

In reality, most of the people who enter the Kunstmuseum of Basel wander around the different floors of the museums, looking at the hundreds of paintings and sculptures and other art objects and are, whether they admit it or not, profoundly bored. There is actually a deep honesty to this boredom, especially when it is expressed openly in acts of yawning and shuffling and distraction. The truly strange thing would be to see a person stop before Franz Marc's painting and to begin to tremble and shake, to hide her eyes, to shield her face, to glimpse out from under her arm furtively at the work that hangs before her. Such a person, if observed, might very well be ushered out of the museum by the guards, perhaps asked gently whether she was okay and needed medical assistance. She might be considered of unsound mind.

To Franz Marc, of course, it would be precisely a mark of sound mind to stand before his picture and to shudder and to shake. To stand before his picture and to realize that it is an eruption of the unconditioned into the realm of the conditioned would be to see the reality of the painting, to see what it tries to make visible. And so it would take, in fact, a particularly sound mind in order to be frightened by the painting. Sound in the ancient sense of the term. Sound in the sense of having depths that go down, that touch, within one's own being, the places where one's own being overlaps and blends together with that which, in one's own soul, is beyond oneself.

What, exactly, is a prophet?

To be sound in that ancient sense would be to respond to Franz Marc's painting with the kind of physical reactions that are akin to the fear of God. Someone who could really see Franz Marc's painting might begin to vomit and to rend her own clothing and to tear at the skin of her own face. This would actually make a great deal of sense, though it would, admittedly, make very little sense to the people of Basel and to the other visitors at the Kunstmuseum, visitors expecting to have a nice time and to "see some art" and to have a lovely espresso and delicate pastries later in one of the impeccable cafes of the museum or the surrounding neighborhood. Such persons would not tolerate a woman standing before *The Fate of the Animals* and ripping her garments to shreds, reducing her own clothing to sackcloth and endeavoring to smear her own hair and face with ashes, letting out a guttural howl, perhaps a terrible and screaming moan that would echo through the white and pristine halls of the Kunstmuseum of Basel, a screaming howl that would crack glass and set the minds of the other museum-goers to confusion and frenzy, a frenzy that might, just might, thrust them into manifestations of their own madness, their own descent into ashes and sackcloth, their own mania, running through the halls of the Kunstmuseum of Basel tearing paintings from the walls and throwing sculptures to the ground in wild acts of debasement and pity and self-defilement appropriate to the state, the actual state of their humanity, of our humanity, of the shared fate of us, of all of us, of all the animals.

16. A prophetic painting is an apocalypse. A revelation.

IT IS HIGHLY UNLIKELY, TO SAY THE LEAST, that any such event will transpire at the Kunstmuseum in Basel, Switzerland. D.H. Lawrence says somewhere in his strange book *Apocalypse* that the people of today's civilization are paper-thin. They range widely in their knowledge and interests and are more or less bored and deadened by the world, by whatever they survey before them, which is accepted as so much visual information, so much audible information, so much data, so much that is either more or less entertaining.

What would it take for people such as us truly to be terrified? Not scared or upset, but truly terrified. Not fearing for our lives at the moment of death, or during a sickness that cannot be cured, or at the onset of a car accident. Not the physical fear of some form of violence that may be about to occur, but the feeling of terror before the overwhelming drama of life itself. Not fear of death, but fear of life. Fear in the sense that one is completely suffused with the sense of life's importance. And that importance becomes a source of trembling, a

A prophetic painting is an apocalypse

trembling that reaches down into the very roots of one's being.

What kind of lifeworld would it take, what kind of civilization would it take, to face the question of life and to be terrified before it? To stand and to tremble under the question. What chance does a person have today of even recognizing the question, of seeing that the question is even a question, of being able to do anything but laugh at the question "what is a life?" or to make fun of it, or to be bored by it. Most people are only able to stand before Franz Marc's painting in Basel and be mildly amused by the colors and by the size of the painting, which is rather large and bold in its color and in its design, the shafts of color that seem to shoot through the bodies of the animals that are depicted in some abstraction on the canvas.

Then, having looked for a few seconds, the instinct is to turn away before it becomes boring. There is another canvas to look at a few feet away. And so boredom ranges from canvas to canvas, from artwork to artwork. The contemporary person is not to be too heavily blamed. What are we to do, anyway, in the face of a work of art? We don't know. We don't know how to stand or how to look, what thoughts to have. How could we? What, exactly, are we doing in the museum anyway? We are performing some sort of rite. But it is a rite that seems to have lost its reason for being.

If we are honest with ourselves, we don't know why we are there, other than that we are supposed to be there. That art is important, somehow, we have learned.

But we haven't learned a good answer for why it is important. We haven't ever had any experience with art that amounts to more than trifling, some dim sparkle of interest at the image before us, or the great technique being displayed, some general satisfaction at being physically present before such-and-such Great Work. Some need to document and share the fact that we have stood before such and such Great Work. And when this empty modern pilgrimage has been completed, we walk away feeling satisfied that we have performed the task, but feeling also a general sense of unease. The unease comes from wondering whether it all hasn't amounted to some kind of trick, some giant boondoggle in which we've been counted as fools.

What rarely, if ever, occurs to those who view *The Fate of the Animals* today is that the painting achieves an infinitesimal breaking through of another world into this world. The painting should be, wants to be, a glimpse of a truth that is beyond the world, a glimpse that comes from within the confines of the world that actually exists. It is a bit of prophecy hanging latently on the wall in Basel, Switzerland. Such bits of ancient prophecy can be found all over the world. Mostly, they occupy the current world in a state of inertness. But within this state of inertness languishes a potentiality. In this sense, everything that is prophetic, words or actions or works of art, threaten to break the bounds. Prophetic words threaten to break the bounds of language and how language normally works. Or they

A prophetic painting is an apocalypse

threaten to break the bounds of behavior, how behavior normally operates.

The prophets of the Hebrew Bible, for instance, are often wild people. They behave in ways that push them to the limits of acceptable behavior. They break the confines of the societies in which they live. Often, prophets head instinctively to the outskirts. They go to the liminal places. They seek out caves and deserts and mountaintops. It is from these marginal places that they can shout and proclaim and behave in ways that are not held within the normal rule structure of the society from which these prophets emerge.

Prophetic painting then is painting that operates in the same space as the speaking of the sibyl or the actions of the biblical prophet. Franz Marc can call such painting a painting of the "future" for the simple reason that he held an essentially eschatological viewpoint of history. That's to say, he saw that there was a possibility in the world in which he lived, the world of Europe leading up to World War I, the war that led to the Battle of Verdun in which Franz Marc was to lose his life in the bursting of a shell; until this very moment of death, Marc saw that there was a constant possibility that the sorts of truths revealed in his paintings would also actually reveal themselves in the world, or become real in the world. That's to say a revelation, which is the same thing as an apocalypse. Revelation and Apocalypse.

We must understand that all of the painting of Franz Marc is nothing but the painting of revelation and the painting of apocalypse. We mustn't forget, because

The Fate of the Animals

Franz Marc never forgot, that the word "apocalypse" is simply the word "revelation." Revelation is the Latin version and Apocalypse is the Greek version of the same word, the same thought. The modern mind reels at the simplicity of apocalypse. Apocalypse is not the destruction of the world, not primarily. Of course it might very well be true that the reality of revelation, the truth of revelation would mean, by logical necessity, the destruction of what actually exists now in its pre-revelation. Perhaps we cannot get away from some notion of destruction when we think of apocalypse and revelation for the simple fact that revealing what is beneath our perceived reality also must therefore be a threat to that perceived reality. The threat of destruction, some kind of destruction, is always present when talk of revelation and apocalypse is present. But this is only as a kind of corollary. Destruction is a possible implication of apocalypse, but it is not its inner meaning. The basic and simple meaning of apocalypse is just that something is revealed, something is brought forth into the light.

Franz Marc's paintings are about the future insofar as the future is always the place where truth might break through, might make an appearance, a true revelation. The hope that the world might become what it was always meant to be, that it might become a true expression of what it really is, that those who are asleep might wake up—these are the hopes that drive the prophets, these are the obsessions that torture the living days of the prophets, prophets like Isaiah or

A prophetic painting is an apocalypse

Ezekiel or Franz Marc. Prophets call out this possible truth-to-come into the wilderness of the barren ears of the people all around them, knowing full well that they will be misheard and misunderstood and ignored. They know that the message is structurally difficult, that it will be hard to receive by its very nature. Sibyls and prophets speak in the hope that the eschatology of fate is behind them, or might be behind them, or that the eschatology of fate will take up what they have sent forth into the world as an opportunity for making the truth that opposes the world into the truth that shapes the world.

The prophetic statement, or the prophetic showing-forth that stands at the core of Franz Marc's painting, stands there in the form of a tree. You might not notice the tree in Marc's painting, not the first time you view the work. The tree looks like it could be just another of the rays of light and color that shoots through the painting. A little bit of study, however, will reveal that there is a massive, structurally defined, and brownish element that makes its way from about the top middle of the painting down to the bottom right-hand corner of the painting.

This element is not a ray of light or a Cubo-Futurist refraction such as can be found in many other places on the canvas. This element is the trunk of a great tree. The tree is in some trouble, perhaps. It might be a tottering tree or even a falling tree. Or perhaps we are simply in such a chaotic and dangerous scenario in this painting that everything can only be seen at an angle and from

a skewed perspective. There is also, we should note, another bit of tree on the far left side of the painting. This tree has been cut, sawed right through, or perhaps blasted right through by the same sharp and powerful forces that are let loose on the surface all around the canvas.

However it has happened, the tree on the far left side of the canvas has been cut and the rings of the tree are clearly visible. This painting by Franz Marc is thus, obviously, about animals, but it is also quite obviously about trees. We're tempted to call this a nature painting. But what kind of nature is this painting showing us? This is not nature as we normally see it. This is nature, Franz Marc might say, as we normally fail to see it. This is nature as it shows itself beneath the surface. Or nature, we could say, as it reveals itself in the light of truth.

But the light of this particular truth, the truth of *The Fate of the Animals*, is shot through with so much confusion. Most people come to view the paintings of Franz Marc, and especially this painting by Franz Marc, in the mode of some degree of visual confusion. This is only natural. You can't see real things, really real things (in the world or in paintings) when you rely on your eyes as mere scanners of the surface, Marc would say. You have to let your eyes guide you beyond your eyes. The eyes only go so far. Then they reach a limit and the seeing of *Geist*, the spiritual seeing, we might say, takes over from that point forward. You are never going to see a painting by Franz Marc until you see it *geistig*. That's the argument, anyway. That's the effect that Franz Marc

A prophetic painting is an apocalypse

wanted his painting to have. He wanted the painting to be impossible to be looked at in any normal way. He wanted the painting to change your seeing.

We've already understood how important the term *Schicksal* was to Franz Marc and how the sense of Fate or Destiny guided him even in his decision to enter World War I as a soldier and to accept the *Schicksal*, the Fate, that had come to him and to all Germans, and to all Europeans for that matter, in the specific destiny that had culminated in the events of the world war. *Schicksal*, as we've already discussed, is not just a force beyond but a force within. One has to accept *Schicksal* and to make *Schicksal* one's own. You bow to your fate, yes, but you also choose your fate. Choosing and bowing go together and become different sides of one unified act, you might say. *Schicksal* is not the opposite of freedom, the way a man like Franz Marc looked at it. *Schicksal* becomes an expression of freedom because a person becomes truly what that specific person is by taking up and choosing the *Schicksal* that is one's own. This idea is at the knife's edge of becoming a contradiction, of being incoherent. But in the end, it is not. There is sense to it, a sense that Franz Marc was trying to work out, to express on his famous canvas that took the title *The Fate of the Animals*, or *Tierschicksale*, a German word in which you can see the root word *Schicksal* embedded right there: the Animal-Fate.

17. In which we explore some of the other names, the hidden names, of the painting *The Fate of the Animals*, and in which Paul Klee, the great and beloved foil to Franz Marc, enters the picture, figuratively and literally.

BUT THOSE AREN'T THE ONLY TITLES of this difficult painting. Today, the painting is known as *The Fate of the Animals*, as *Tierschicksale*, but it has other names. The other title of Franz Marc's famous painting was a title suggested by the artist Paul Klee, who had become a friend to Marc in the couple of years between Marc's *annus mirabilis* (from the end of 1910 and into the beginning of 1911) and before Franz Marc went off to fight in World War I. Paul Klee survived the war, mostly because he was never brought up to the front lines like his fellow artists August Macke and Franz Marc. Because of this, Paul Klee lived many years after World War I and only died in 1940, in the early days of the next war, the follow-up war to the war in which Paul Klee lost many of his friends and fellow artists. During the time that Klee was associated both

Hidden names of *The Fate of the Animals*

with Franz Marc and also Wassily Kandinsky, he had become fond of Marc and his paintings and suggested to Marc that a possible title for the painting that we now know as *The Fate of the Animals* (*Tierschicksale*) could be "the trees show their rings, the animals their veins."

It is a more descriptive and less title-sounding title than *The Fate of the Animals*. It refers to the aforementioned rings on the tree that is cut in half on the far left side of the painting. A man like Paul Klee, a deep thinker and inquirer into nature, and into the mysteries that make nature act and function and proceed just how it actually does act and function and proceed, an artist with a deep feeling for the twists and turns, the surprises and the organic leaps, and the amusing playfulness and the sometimes heart-stopping audacity of nature as it grows and moves—an artist like Paul Klee, so attuned to these naturings of nature, was also well attuned to the part of Marc's painting that deals with organic forms, with growing things.

Klee was a less harsh man than Marc. Klee was not a figure of sackcloth and ashes the way that Franz Marc was a figure of sackcloth and ashes, and Paul Klee did not throw himself into the fate, the destiny, of Europe's destroying of itself in the beginning of the twentieth century in the way that Franz Marc did. Klee held himself back from all the passion and the terrifying and self-destructive resoluteness into which Franz Marc threw himself completely. Klee did not buy all the fervor—he held it, no doubt, in some suspicion, which

surely has something to do with why Paul Klee survived World War I and Franz Marc did not.

Paul Klee, unlike Marc, was an artist of nature in its subtlety and in its play. He was an artist of the small and intense and convoluted inner development by which nature articulates itself slowly by emerging slowly from within itself, and by showing secrets as the organic works upon itself and layers over itself and emerges from its own strange and always startling logic. The difference between the work of Franz Marc and the work of Paul Klee can probably be captured in the word "comedy." There is great joy in some of the paintings of Franz Marc, especially the paintings in which we are shown the *jouissance* of animals. The joy is abundant. But there is never comedy. The joy is too closely allied with suffering. The joy is a form, also, of pain. This joy is not the joy of humor. The prophets are, as a rule, not an especially comedic bunch. Not intentionally anyway. There can be something funny about prophets in their absurdity, in their craziness, in their flouting of all social convention. Prophets can be funny to the rest of us. But they don't mean to be funny. They are generally quite serious about themselves. And even our laughter in the face of prophets has a quality of unease. You laugh at the prophet in sackcloth and ashes because the prophet makes you uncomfortable. What does he know? Why is she upsetting the way of things? To what am I being called? These questions are suppressed, by us, with our laughter. The laughter is meant to combat the intolerable seriousness of the prophet. And Franz

Hidden names of *The Fate of the Animals*

Marc was definitely a painter of intolerable, of nearly overwhelming seriousness.

Paul Klee was not. His mission was different. And so he was rather more deeply attuned to the comedic. Klee was interested in the strange and surprising and sometimes completely hilarious ways that nature creates its forms and then breaks away, or finds new ways to operate within those forms. Nature is playful in a way that presses right up against the absurd. Nature comes up with funny solutions to its own problems. Klee would work with his pencil or with watercolors on paper and reproduce this very process of nature playing with itself, playing with its own forms. Klee would go out and take his lines for a walk, as he once and famously put it. He could inhabit this sensibility. That was the genius of Paul Klee. He had a felt sense for the rules of this or that specific form, and he knew how to worm and wiggle and improvise within that given form just like nature does when it creates a plant that goes this way instead of that, or an animal that develops a hilariously long snout to get into this or that plant, which itself has grown long and spindly to deal with some other formal problem of growth or development given to it.

Klee spent a whole long life and career working in this territory of nature and form and the dialectical push and pull that results, the tensions that result from the establishing of natural forms and the unexpected ways that a specific entity will take up the challenge of natural form in order to become this specific thing or that specific thing and you could never have guessed it,

never have anticipated just which way the specific entity would have gone until it got there. Paul Klee's paintings and drawings prove, as it were, over and over again, that nature is inexhaustible and that this fact is a constant source of delight and wonder.

It's interesting that Paul Klee made a painting in 1917, during his own time as a soldier but a non-combatant soldier in the German Army in World War I. The painting is known as *Ab Ovo*. It should be noted that *Ab Ovo* is a painting made on a scrap of gauze. And what is gauze really, in the context in which we are discussing paintings and prophecy, what is gauze but a kind of sackcloth? And what did Klee use as material by which to prepare this sackcloth? He used, partly, chalk. He put chalk and paper over the gauze, over the sackcloth, in order to give himself a foundation upon which to apply his watercolors, which would simply have disappeared into the sackcloth without the support of the chalk and the paper.

So, we can say that Klee took this chalk, these ashes as it were, and smeared these ashes over his sackcloth in order to make a painting, and during the maelstrom of the year 1917, a year in which the final hellish battles of World War I were burning themselves out all across the world, he smeared his ashes on his sackcloth in order to make a painting that is about the birth of all things. It is incredible, really, that Klee should have made such a painting given his friendship with Marc and his experiences in the war and his own studies of nature and of the surprising and delightful ways that nature

Hidden names of *The Fate of the Animals*

makes forms and follows the logic of these forms into the wondrousness of all that is.

The amusing thing about *Ab Ovo*, in such direct contrast to *The Fate of the Animals*, is that *Ab Ovo*—for all of the historical chaos and terror in which it was painted, for all the drama of cosmic birth and destruction which it seems to address, for all the portentousness with which its material condition of ash and sackcloth would seem to imbue it—is quite calm. There is indeed an egg in this painting, an *ovo*. And the egg is cracked. But the crack is not like the cracks, the streaks, and the wild slashes of color and form in *The Fate of the Animals*. The crack in the egg in *Ab Ovo* is just a crack. And something is emerging from the egg. Some sort of new form is coming forth from the egg, and that's that. Such things will happen. Such things must happen. Form begets form. Old object begets new object. Living thing begets living thing. There is nothing to get excited about here. Even in the midst of 1917. The Russian Revolution has broken out in full force. Germany has resumed unrestricted total war on everyone. The US is entering the war. Lenin is taking his famous train ride. The Battle of Passchendaele is raging along the trenches of Belgium, a battle so horrible it ought to be in the category of unmentionable things. And Paul Klee makes *Ab Ovo*, a painting in which we learn about the way an oval is related to a triangle under the eye of a crescent.

And yet this person, this Paul Klee, this artist of the dispassionate play of form in the infinite game

The Fate of the Animals

of nature, this person who witnessed the hell and trauma of World War I but was also, somehow, able to hold some part of himself in reserve, was able to let it pass over and through him, was able almost to ignore the historical reality raging all around him, who was also able to paint a painting like *Ab Ovo* with ash and sackcloth during the cataclysmic year of 1917—this man whose constitution could not have been more different than the constitution of Franz Marc, this artist named Paul Klee was to have a profound effect on the painting that we know as *The Fate of the Animals*.

So in a way, *The Fate of the Animals* is two paintings. It is Franz Marc's painting, titled *The Fate of the Animals*. And it is Paul Klee's painting, titled *Trees Show Their Rings, Animals Their Veins*. Even this title is so very Paul Klee, is it not? He ignores all the violence of the picture. He ignores the portents and the prophecy. He goes directly to the laconic. He goes to the formal and organic similarities in the painting. Rings are to trees as veins are to animals. What an interesting thought. You can imagine Klee's brain, his hand that loved so to draw, you can imagine him lapping up all the possibilities of this comparison. You can imagine him dancing the loops and curves of his line through the rings of the trees and the veins of the animals.

18. The drama of Paul Klee and *The Fate of the Animals* becomes even deeper and more surprising, and we begin to realize that the painting *The Fate of the Animals* is itself an object of fate, with perhaps also a little dash of grace.

IN FACT, THE INFLUENCE OF PAUL KLEE upon the painting is even more profound, even more incredible than so far described. It also so happens that Paul Klee is not only an influence on the painting because of his friendship with Marc and because of his suggestion of an alternate title. Paul Klee is also, literally, a painter of the canvas. This is because of what happened to the painting after the death of Franz Marc. The very same year that Franz Marc died in 1916, there was a fire in the warehouse in which *The Fate of the Animals* was being kept.

This fact alone is difficult to accept as a mere accident. It seems incredible that the painting that most powerfully renders all of Franz Marc's deepest intuitions about art, about life, about meaning, about suffering, would burst into flames soon after his death. It seems

incredible that a painting which portrays cataclysm and a kind of cosmic fire, the lightning and fire that tears apart worlds, that this painting itself would be caught in a cataclysm of destruction and fire. The symbolic significance seems almost too much. Did the painting, with its own power to evoke apocalypse, call down a kind of mini-apocalypse upon itself? Of course it did not. There was simply a fire in a warehouse. Such things happen all the time, especially in times of war and upheaval. The idea nevertheless nags at the edges of the mind, the idea that this of all paintings would be caught in a conflagration, and that it would take on the actual physical scars of war and of crisis and of fire.

Whatever the case, whatever the cause of the fire that scarred *The Fate of the Animals*, it was, in fact, badly damaged, though not destroyed, in a warehouse fire in 1916. The fire happened, reportedly, on the very night that the painting was to travel from Berlin to Wiesbaden. The painting had been in an exhibit that was a memorial to the art of Franz Marc and that exhibit, seven months after the death of Franz Marc, was to travel to Wiesbaden the following day. But a fire happened instead, and the painting was badly damaged. The entire right side of the painting was burned beyond recognition. Franz Marc's friend Paul Klee heard about this fire and about the damage to the painting. Over the next several years, Klee looked at color studies for the painting and at various photographs that had been made of the painting before it was damaged in the fire.

An object of fate

Then, in 1919, Paul Klee undertook to restore the fire-damaged painting.

Paul Klee did, indeed, restore the painting. He took his own brush and his own colors and his own hand and he began to paint on the canvas that had once been painted upon by his now-dead friend Franz Marc. One can only begin to imagine the thoughts and emotions that were coursing through the body of Paul Klee as he worked on the painting of his friend and colleague, killed on the battlefield of Verdun just a few years before. Or maybe he was not overcome with emotion. Maybe Klee could only do it because of the very same dispassion, the very same reserve that had allowed him to paint *Ab Ovo* during the absolute catastrophe of 1917. Maybe Paul Klee, a kind of complementary opposite to the sensibility of Franz Marc, was, in fact, the only person who could have taken up and restored the damaged painting by the now-dead Franz Marc.

More deeply than most artists of the time, Klee was positioned, both due to his own artistic sensibilities and because of his personal friendship with Franz Marc, to do justice to the meaning and purpose of Franz Marc's painting. Had he desired it, there is little doubt that Paul Klee could have restored *The Fate of the Animals* to more or less the exact condition it was in before the unfortunate, or fateful, warehouse fire of 1916. Klee certainly had the painterly and artistic skill to do that. He also had the knowledge and the understanding of what Marc had been trying to do on that canvas.

The Fate of the Animals

But Paul Klee chose not to restore the painting to exactly the condition in which it would have been found before the fire of 1916. The right-hand side of the painting that was destroyed in the fire depicted four deer standing side by side arranged around the tree that is the center structure of the painting. It also depicted a number of other trees, some of them bifurcated so that we could see their "veins." There were also a number of rays or bolts of color that shot through this side of the painting just as they shoot through the rest of the canvas.

Paul Klee reproduced these elements exactly as they existed in the original painting before it was damaged in the fire. What he changed was the color. Franz Marc's original painting is dominated, as was typical for Marc, by the strong presence of primary and secondary colors. Red, blue, green, yellow. The deer in the center of the painting is a startling blue. There are two green horses toward the top left of the painting. Rays of red and yellow and orange shoot through the painting from all directions. But Paul Klee did not reproduce these colors. He did reproduce the rays, and the animals, and the trees. But he painted them all in a kind of dull brown that mutes the colors completely.

There has been much speculation by art historians and critics as to why Paul Klee decided to perform his painterly reproduction of the right side of *The Fate of the Animals* in brown. Paul Klee himself was silent on the matter. Most of the things that people write about Paul Klee's intentions are probably true. Probably, Klee chose

An object of fate

to paint his section in dull brown for the obvious reason that he didn't want to produce a "forgery" as it were. He didn't want to make it seem as if he, or anyone else, was trying to fool anyone. The painting was burned in a fire and then restored. Paul Klee restored the painting in such a way that the restoration has now become part of the painting. That's to say, it is a restoration that is honest about the fact that it is a restoration. The painting now proclaims, "I have been restored" in no uncertain terms. And the brown is a testimony to the fact that the painting was burned, that the color was burned out of it.

It is also a testimony to the fact that Paul Klee, great artist, great painter that he was, was, nevertheless, in his job of restoring his friend's painting, taking a kind of secondary role, a humble role. The vibrant colors and movement of Marc's original painting stand forth, now, on the canvas. The restorations by Paul Klee, because of the dull brown color, recede more into the background. Thus Klee restored a sense of the whole without, at the same time, effacing the reality of the painting's history. We get to see the whole painting, and we also get to see exactly where it has been damaged, where it has been marked and scarred by actual history. That is part of the painting now, too.

Paul Klee ensured the fact that *The Fate of the Animals* is not just a painting created by Franz Marc in 1913, but a painting that continued to be created. It was recreated also in 1916 by the happenstance of a fire. And it continued to be created in 1919 by the restorative

The Fate of the Animals

brushwork of Paul Klee, and, indeed, it has continued to be created in all the years since then by the subtle changes that weather and time and atmosphere and all other manner of effects that get into the warp and woof, as it were, of a painting and, over the years and centuries, shift and change the painting as a visual object.

All of these matters were surely in the mind of Paul Klee as he did his work of restoration on *The Fate of the Animals* in 1919. Some of these concerns may have been at the forefront of his mind, others of these concerns may have been latent—unconscious, as they say—as Paul Klee put his hand to restoring the painting and gave himself over to his intuitive sense of what he should and shouldn't do to the painting.

But there is something deeper also, I think, in what happened to Paul Klee as he confronted this painting by Franz Marc and as he tried to be respectful and diligent in his job of restoring a painting that had been damaged in a fire. Paul Klee was well aware that this painting is not just any painting. He was aware of the difficult and, one might even say, dangerous nature of the painting. Klee was aware that the painting seemed to be some kind of premonition of The Great War, and he was aware, even more deeply than that, of the way that the painting was a visual testimony to the struggles and the passions, to the kind of prophetic visions that were coursing through the person of Franz Marc in 1913 as he painted *The Fate of the Animals*.

Paul Klee was aware of all these factors in the art of Franz Marc, and he was also not entirely comfortable

An object of fate

with all of these forces. Paul Klee would have been the first to admit that he himself was not an artist of those kinds of passions, not of those sorts of prophetic forces, nor of the sensibility that would make a work of art that depicts the destructive powers of creation and uncreation, or that dabbled in such seemingly deep questions as to what fate is and what fate might mean when it comes to animals. Paul Klee, in his own writings, often referred to such artists as being "Faustian." They are Faustian because, like Goethe's Faust, they can't stay away from the hot center of things, as it were. They want to go into the fire and see what is cooking on the inside. They are drawn there. They know that they will get burned, but they must go. In this sense, Franz Marc was indeed the most Faustian of artists. And Paul Klee was indeed the least Faustian of artists.

So even though these two artists admired and respected one another quite deeply, there is also a deep chasm that separates the Faustian from the non-Faustian artist. And it is this deep separation in terms of goals and attitudes and sensibility that is now, also, painted onto the very canvas of *The Fate of the Animals* by means of Paul Klee's restoration. It is almost as if *The Fate of the Animals* could not stand to be in the world. It was too hot. It was too crackling with apocalyptic powers. It was too much for the canvas to bear. And so the canvas burned itself up, in part. And then Paul Klee came along. And he knew, instinctively, that the only way to keep a painting like *The Fate of the Animals* in the world would be to cool it down a little. Klee was

the artist who could cool it down. Klee was, after all, the artist who had already looked past the hot fire of the painting, had already seen the infinite play of nature and its forms behind the *Sturm und Drang*, and had renamed the painting *The Trees Show their Rings, The Animals their Veins*.

Paul Klee, in short, repainted Franz Marc's painting in a way that was both a tribute to the original painting and also a challenge to the very impulses that caused Marc to paint as he did. There is a tiny rebuke in Paul Klee's restoration of Franz Marc's painting. Perhaps not fully conscious, not fully intentional, this rebuke is almost, somehow, necessary. One painter painted a canvas that, by its very nature, could barely exist, was too hot for being in the world, and had the tendency to burst into flames. The other painter, a painter who accepted the boundaries of life, the formal constraints that allow for the normal cycles of life, this painter stepped in to "correct" the earlier, impossible painting. He fixed it up so that it could live in the world. And by so doing, he also muted it. He toned it down. He cooled it off. He made it a painting not about fate, but about showing, about how creatures show themselves. And so the one painting is, now, actually two paintings.

But we are not quite done with multiplying paintings. That's because *The Fate of the Animals* is not just two paintings, but in fact three paintings. There is another title.

19. We discuss the third title of *The Fate of the Animals*, which is the most secret title of all, and which brings us to the heart of the matter, perhaps the heart of everything, if we can be a little portentous about the matter.

A T SOME POINT IN THE MAKING OF THE painting, Franz Marc jotted the words "And all being is flaming suffering" on the back side of the canvas. Today, as the painting hangs at the Kunstmuseum in Basel, Switzerland, it is impossible to see those words. They are on the back of the painting, as mentioned. But they probably should constitute the third true title of the painting along with the other two.

Or perhaps no words should go along with the painting at all. At his purest moments, Marc might very well have preferred it that way. The painting would be the painting, and that is it. Words only get in the way. The pure relationship between seeing and Seeing would be preserved. Those who understand the painting would understand the painting. Those who do not understand the painting are never going to understand the painting

anyway. They are never going to make the jump from mere looking to the work of *Geist*, the work of Spirit that allows the painting truly to be seen. That's how Franz Marc might very well have considered the matter, had he sat down and tried to come up with a position on whether or not there ought to be words connected to the painting *The Fate of the Animals*.

On the other hand, Franz Marc was a man of words, a man of discursive reason, a man who took it upon himself not just to write but often to write specifically about art and, moreover, to write about the very art that he created, the paintings that he created. He was not able to disentangle words from painting. It is appropriate, then, that Franz Marc wrote words on the painting *The Fate of the Animals*. He wrote the words on the back of the painting, true, but they are there, physically, on the painting nonetheless. The painting is a painting of words almost as much as it is a painting of images. The words, "And all being is flaming suffering," are part, now, of what the painting actually is. It is those words, just as it is the images of the animals in various states of distress and the shooting streaks of color and the giant tree and the tree that has been severed and shows its rings. The words "And all being is flaming suffering" are, it has been noted, taken from the Vedas. The Vedas are the ancient Hindu scriptures that make up the holy writings of that religion and are among the oldest surviving texts in any religion, going back to the beginnings of the second millennium BCE.

The third title of *The Fate of the Animals*

If Franz Marc was consciously referring to the Vedas when he wrote "And all being is flaming suffering" on the back of *The Fate of the Animals*, then it is probable that he got to know something of the Vedas through his reading of the texts of Friedrich Nietzsche. Friedrich Nietzsche got his understanding of the Vedas, as is well known, from his reading of Arthur Schopenhauer, who read of the Vedas through his own studies and through the translations of the sacred Indian texts that had been published during Schopenhauer's lifetime and made some impact on European intellectual circles. Nineteenth-century Europe, and Germany in particular—though there was not even a proper country called Germany, or Deutschland, in the sense we think of it today until the declaration of the German Empire and the Reichstag in 1871 (Schopenhauer had already been dead for ten years)—but Germany in particular, and certain European intellectual circles more broadly, were ready to hear what they interpreted as the mainly pessimistic spiritual message of the Vedas, a message in deep contrast to the more or less optimistic message of the late Enlightenment and the early phases of the Industrial Revolution, which promised, though there were certainly many doubters at the time, that the fundamental problems of human society, and therefore, implicitly, of being human altogether, were on the cusp of being solved.

One of Schopenhauer's central insights, inspired partly by the Vedas and by the Upanishads, was (to drastically oversimplify the matter) that there is no such

thing as "solving the problem of being human" since the "problem of being human" is not an accident, a mistake, something that can be corrected. The problem of being human is structural, you might say. It is a condition and that condition is written into the code, as it were. That's to say, the very fact of being human is "to be a problem," and therefore to solve the problem of being human would be to cancel the condition of being human.

The only way to solve the problem of being human, Schopenhauer essentially said, would be to cancel human beings altogether. If every human being were dead, the thinking goes, then perhaps the problem of being human would be solved. Schopenhauer, in this sense, was anticipating the blood pump of the Battle of Verdun. Just kill everyone and problem solved. Otherwise, there is no solving the problem, since the problem simply *is* the being. The "being" of being human is the being of a problem. That's a root thing, a core issue, a foundational statement. The spade turns there. There is no getting under the ground on which the spade falters. And so, the idea that we are going to "progress ourselves" out of this problem, into another mode of being and into a potentially more satisfying form of existence, is a failure to understand the nature of existence itself.

The nature of existence itself, Schopenhauer suggested—and here he considered himself in line with the ancient wisdom coming from the subcontinent—is simply a massive and relentless and irrepressible striving that is anarchic, meaningless in any sense of the term

The third title of *The Fate of the Animals*

that makes any sense, and without any purpose other than the continuation of that restless and unfathomable striving. Being human is simply being part of that bubbling mass of empty striving, nothing more.

Human beings may be conscious of their situation, but so what? So what that you're conscious of your situation? That consciousness does not give you even one tiny iota of power with which to alter the situation. You will be thrown, you are thrown, as a single human being, into the mass of striving and then, mercifully, you will die. The question of your happiness in the face of the bubbling mass of surging strife is a laughable one. It is, in the purest sense of the word, a joke. The closest thing that a person can experience to happiness is a kind of surrender to the brute fact of the matter. The brute fact of the matter is that your life is of utterly no consequence beyond the rather indifferent fact that you are simply one tiny node of pointless striving that will soon go away. Reconcile yourself to that fact as best you can and your life will, at least, be free of the pointless and exhausting work of making it into something it most assuredly is not.

Pretending that your life is meaningful in any way, Schopenhauer thought, is hard work. And it is pointless work. Because it isn't true. There is no standpoint from which you could truthfully see your life as meaningful. There is no meaning in the bubbling surging mass of striving-forth that is the actual and true center and core of existence. There is nothing there but the surge. Surrender to the surge, Schopenhauer said, more or

less, and at least you won't live a life of painful illusions. You'll be cured of the incessant, psychologically damaging work of maintaining the fiction that there is anything other than the surge.

That is Schopenhauer's definition of happiness, such as he had a definition. Perhaps it would be better to call it a re-definition since most people would say that, defined in Schopenhauer's way, happiness is essentially another way to describe unhappiness. Most of the time, Schopenhauer would have agreed. The only way to experience happiness, Schopenhauer would have said, is to redefine it as what most people would consider a kind of resignation in the face of despair. That, anyway, is the wisdom that Schopenhauer extracted from the Upanishads and from the wisdom of the subcontinent such as he understood that wisdom through the lens of his own post-Kantian Teutonic sensibility.

The thread of this sort of thinking was passed down to Franz Marc by way of Schopenhauer's most brilliant reader and interpreter, Friedrich Nietzsche. It was one of Nietzsche's contributions to connect this Schopenhauerian strain of Upanishadic thinking to the pre-rationalistic, that's to say the more "oriental," as Nietzsche called it, the eastern side of the Greek mind as it existed just-on-the-cusp of the classical era. It was Nietzsche's innovation, in short, to suggest that the dark thought at the heart of Indian religious and spiritual practices was already there, already embedded in the European mind, as it were, by way of the Greeks, who carried a form of this deep and disturbing insight

The third title of *The Fate of the Animals*

within their own cultic practices and within their own forms of art, most notably, in that unique form of Greek aesthetic/cultic practice known as tragedy. The same Vedic and Upanishadic thoughts about the surge and the empty striving that is life are also found embedded in the darkest heart of Greek tragedy, Nietzsche thought. This was his primary insight. Right or wrong, it's what makes Nietzsche Nietzsche.

So, when Franz Marc wrote, on the backside of his famous painting, that "all being is flaming suffering," he was channeling thoughts that had been lingering in the Teutonic mind for quite some time, about a hundred years, ever since Schopenhauer picked up the books of ancient Indian religious thought and began the project of transmuting those thoughts into the language and categories of post-Kantian German philosophy.

In a deeper sense you could say that the thought was there all along, embedded from the start. And the thought emerges again, sometimes like waves rolling in from the deep. These waves, these ripples of ideas moved ever outward through the years and into the minds of different individuals who picked up on them, notably that difficult person and difficult thinker of the mid- to late part of the German nineteenth century, Friedrich Nietzsche. With Nietzsche, the thoughts that Schopenhauer was trying to get at were stripped of their unnecessary semi-Kantian baggage and given a new and fresh form of expression. The result was Nietzsche's aphorisms and his proto-religious style of world-historical declarations. What came from plumbing the

The Fate of the Animals

deep Vedic soul of Greek tragedy was Zarathustra and the mytho-poetic fragments that constitute Nietzsche's literary style. These writings became dear to Franz Marc, who saw in them a willingness to confront the crisis of contemporary man and the civilization that was, ever more blindly, groping in the dark toward a catastrophe.

And so, ever mindful of the deeper truths to which he thought painting owed its allegiance, Franz Marc painted his painting that came to be known in English as *The Fate of the Animals* and wrote the phrase on the back of the painting "And all being is flaming suffering." The use of the word "flame" was, perhaps, unfortunate, since it could create a literal association by which to view a painting that resolutely refuses to be viewed as a visually literal painting.

And, of course, it is not crazy to look at *The Fate of the Animals* the first time and to try to interpret it in more or less literal terms. The most obvious question to ask when looking at Franz Marc's famous painting is, "What is this?" The painting is broken up by all those rays of colors and by the fractured planes across the surface of the painting. Then you see the shapes of the various animals, many of which seem to be in some form of distress. It is as if the world is being pulled apart right before our eyes. Then the mind hits upon the word "flaming." The next step is to imagine that the painting shows us a world that is literally on fire. This must be an apocalyptic painting in the sense that an apocalypse is a terrible, fiery, destructive event. Since it is in fact the case that only a year after Franz Marc painted his

The third title of *The Fate of the Animals*

famous painting World War I did, in fact, break out and did, in fact, cause great fire and destruction throughout Europe and did, in fact, lead to the gruesome death of Franz Marc himself, the interpretation of the painting as a kind of harbinger of the fiery, apocalyptic fate of Europe in the wake of World War I settled down into the more or less standard interpretation of the painting.

But there's an obvious problem.

Franz Marc did not write on the back of his painting "we are approaching an event of flaming suffering" or some statement like that. He wrote, "and all being is flaming suffering." All being. If all being is flaming suffering, then there is no specific reference to any one event in the painting. The painting is about "all being" all the time and not about an apocalyptic moment or some terrible happening that will come to pass or that has already come to pass. More than that, there's no fire in the painting. The phrase "And all being is flaming suffering" does not mean that all being is actually on fire. The flames of the flaming suffering are something other than the flames of physical fire. This painting is not about a forest fire. It is not about heat or about combustion. The idea that all being is flaming suffering says nothing about the relative hotness or coldness of anything. It is not an observation about temperature. The idea that all being is flaming suffering uses the word "flaming" as a word of intensity. It says, "we are not just speaking of suffering in a casual way here, but of flaming suffering."

The Fate of the Animals

What's the difference between a suffering that just suffers and a suffering that flames? It is a difference, at least, in the intensity and, one wants to say, the importance of the suffering. It is as if saying "all being is suffering" isn't quite enough. The sentence is too distant, too detached. The sentence "all being is suffering" is a sentence that the person hearing it could, potentially, ignore. It is a striking thought, no doubt. The claim that all being is suffering is a strong claim. But stated that way, stated as "all being is suffering," it is a statement that lacks a certain sense of urgency. "All being is flaming suffering," however, is a statement that is bold and which contains a great deal of urgency. The word "flaming" is difficult to ignore within the sentence.

It is difficult to ignore and also easy to misinterpret and to misunderstand. Perhaps there is even something deeper than this. Franz Marc painted a painting that cries out in its suffering, that contains within itself a very difficult thought, which is that it's suffering all the way down. If Franz Marc has been successful in painting his painting, then it will also be the case that whosoever looks at the painting will, perhaps despite themselves, be struck, be affected by the force of that thought, of that truth, as it works its way through the painting and into the person of whoever it is that gazes upon the painting. The painting is, if we can put it this way, a dangerous thing.

20. If *The Fate of the Animals* is a revelation, what does it reveal? Can this revelation be spoken? Should it be spoken?

THERE IS THEREFORE AN INBORN, IF unconscious, desire to misunderstand and to misinterpret the painting. It is the same inborn desire that Marc noticed all around him during the last couple of years of his life while he was a soldier in the First World War. He found it very difficult, sometimes, even to fraternize with his fellow soldiers. He was kind to his fellow soldiers, he was a good officer in respect to the soldiers who were under his command. All of the accounts of Franz Marc's comportment during the Great War suggest that he was entirely humane in his dealings with his fellow human beings.

But he also felt a separation. Marc was experiencing the day-to-day matters of the war, but he wrote to Maria on December 24 (Christmas Eve!), 1914 from Mühlhausen, "What makes a soldier's life difficult for me (it would be the same in Munich) is the fact that, next to the service, I have other thoughts and duties constantly in my head and must always lay the service

against the work of my mind and the latter against the service." He is in the war, but he is not fully in the war. He stands somewhat outside of the war, even as he participates in the day-to-day actions and services and performances of duty. But Marc never experiences these day-to-day matters as obvious, as self-evident. "I often envy my comrades who need not be anything but soldiers out here and are not tortured or busy with anything, except a longing for home which I have as much as they do," he explained to Maria.

This situation, Marc freely admits, is the same out on the battlefields of World War I as it would be anywhere else. "It would be the same in Munich," Marc writes. Whether in Munich or on the battlefields of the Great War, Franz Marc isn't able to settle into his experience as if the situation, as if any situation, is simply normal and self-evident. The being of a soldier as being-dutiful is not that hard for many of the other soldiers, at least as Marc sees it. They are able to inhabit, to fully inhabit the fact that they are soldiers and the war is a reality. That is all they need, as it were. They get homesick, as everyone gets homesick, but even this is part of the condition of being a soldier. To be a soldier is to do your duty and to perform your service and to be, in the meantime, homesick. There is a simplicity, even a clarity, to that condition.

This is the clarity that Marc cannot achieve. "But I cannot free myself of my thoughts and dreams," Franz Marc writes. Not only can he not free himself from his thoughts and dreams, "I don't even want to," he

If *The Fate of the Animals* is a revelation

writes. He is in a slightly different state of being, a state of attention that is within the world (he performs his duties and his service) but that is also pulled away from the reality of the situation in which he finds himself. Franz Marc is in the war, but he also sees the unreality of the war. He sees that the war is not really the war. The war is the war, but it is also the realization of something deeper, something more real that is behind and that is fundamental to what the war is, which is merely the appearance. The war is the appearance of something, but it is not the full reality. "The smallest bit of news in the paper, the most ordinary conversations I listen to, have a secret double meaning for me," Franz Marc explains to Maria, trying to give her a sense of this split reality he is experiencing while being a soldier in the war, while being an actor in a situation that many people would say is the most real of real things.

But Franz Marc does not experience the so-called reality of the military life all around him as the really real. "Behind everything," he writes to Maria, "there is something more." He finds himself almost tortured by this realization, by the skill that he has developed to go behind the one reality and see the other reality that lurks in what would otherwise be the shadows but for Marc has a kind of brightness that the well-trained eye can see, the eye that is attuned to the *geistig*, we might say, versus the eye that is simply taking in the surface appearances. "Once you have developed an ear or eye for this," Marc writes to his wife Maria, "it never leaves you in peace."

The Fate of the Animals

This thought takes hold of Franz Marc as he writes his letter to Maria. Now he is becoming excited again. Remember that he has just admitted that, although this kind of double-sightedness can be a torture and that he experiences bouts of envy for the soldiers who are lost in the duties and who do not experience this split reality, he is also grateful for the experience. He cannot get free from his thoughts and dreams, but he also "doesn't even want to." He recognizes his condition as a kind of gift, though a gift that he never knew he desired and never asked for explicitly. The double-looking, the double-seeing is just something that happens to him. Once this ear and eye have been developed, it never leaves Franz Marc in peace. Just after telling Maria about this not being left in peace, Marc writes, "And the eye!" The exclamation mark is his own. He is amazed by the power of his own eye, a power that goes further than he ever asks it to. His eye simply looks out upon the world that is flat and self-evident to most people, and it goes somewhere else entirely, it goes deeper, it sees beyond seeing. "More and more," Franz Marc writes to Maria in his letter on Christmas Eve, of all days, in the year 1914, at the very dawn of 1915, the last full year that Franz Marc will spend upon this earth, he writes, "More and more I look behind—or better—through things, to find something hidden behind its outer appearances, often in a subtle way, by deceiving man with something quite different from what they actually hide."

So this is the mystery and purpose of the paintings of Franz Marc in a nutshell. To make a painting that

If *The Fate of the Animals* is a revelation looks behind—or better—*through* things, to find something hidden behind outer appearances. This is the revelation. This is the apocalypse. This is why Franz Marc's friend Paul Klee first described the famous painting as a painting that shows us the rings of the trees and the veins of the animals. It is a painting that shows us the outsides of things—horses, trees—in order to show that those outsides are hiding something more vital. And the rings and the veins are, themselves, yet another external manifestation. Veins hold and pump the blood, which is the living life-force within.

 Yet an even deeper level, at a level further in and beyond veins and blood, further than what the physical eye could ever see, is the reality of what an animal or tree actually is. There is the *why* of the animal or tree or whatever. There is the "what it is in its being" that the animal manifests. What the *geistig* part of our seeing can see, Marc suggests, is that the animal is neither truly its outer shell, nor is it the inner physical forces and processes that make the outer shell possible. What the animal is, in its deepest essence, is suffering. Not suffering as an unfortunate occurrence that could come about if the animal gets hurt or if something bad happens to it. Suffering as an actual condition of being. All being, in fact, is this suffering. All being is this root suffering, and the root suffering is a suffering of such intensity that it can be described as flaming. That is the hidden truth of the painting *The Fate of the Animals*. It is the truth written on the back of the canvas but a statement that a viewer of the painting, on a visit to the

museum, never gets to see. You are either able to look at the painting truly, or you are not. If you are, then you will not need the words anyway. If you are not, then the words will do you no good no matter how many times you read them.

But we still don't understand why all being is flaming suffering. What does it mean for all being to be flaming suffering? Is existence a kind of punishment? Is Marc's *The Fate of the Animals* meant to show us that it is terrible to exist, or even that it is wrong to exist, that existence itself is the problem? This is the giant question, so large, so difficult to put into words that we bump up against what is essentially nonsensical, or, at the other end of the scale, completely trivial.

What's clear is that Franz Marc was pushing, in his art, toward the elaboration, the expression of a truth that would be so pure, so abstract, so crystalline as to be its own explanation. Transforming this truth into a series of sentences seemed futile to him. If a truth so overwhelmingly pure could be told from one person to the next in clear sentences, then it wouldn't be, by its very nature, the sort of truth that carries with it absolute purity. We are at the problem of the prophet and the sibyl again. We are at the cusp of the need to express the inherently inexpressible. The truth of absolute purity can't be chopped up into discrete thought fragments or bundled into sentence-packages of meaning.

Franz Marc thought about this problem quite frequently. Even as late as December 16, 1915 (a day on which, unbeknownst to himself, he had less than three

If *The Fate of the Animals* is a revelation

months to live), Marc was writing a long letter to Maria from Gemütlich-Leiningen, "cheerful Leiningen!", as he calls it, an area of the German Rhineland where Marc was stationed temporarily on his way to the area closer to Verdun. On December 16, Marc was thinking about the problems of language and of expressing truths that are beyond language. He wrote, "Only poets may succeed in saying something *valid* with words, but that can happen only in the mysterious realm of art, and there, it is said, 'he who can grasp it, may he grasp it.'"

The kind of language we might find in a poem, a poem that somehow circled around the most abstract and pure of truths, a truth like "all being is flaming suffering" is, in language, something of the same thing that Franz Marc was trying to create in terms of color and form, in a painting. To read Marc's painting as a sentence or a proposition, however, would be to lose the purity and the abstractness of it. The meaning of *The Fate of the Animals* cannot be translated into a clear statement in prose. The painting is not "about" some terrible event that will come to pass. It is not a premonition of the war in some straightforward way, as in a prediction about an event on the horizon of history. It does not say that "war will happen" in the same way a pundit predicts that so-and-so will become president of the country on this or that date. Franz Marc had no interest in the Great War as an event in history that could be predicted by reading the socio-historical signs of the times or by having one's nose to the affairs of global diplomacy. Franz Marc's

painting is not a painting about the great worries of his own time.

Marc's painting is about the spiritual, the *geistig* condition of existing in the first place. It is about the inner reality of existence stripped of all the specific, historical conditions that make any existence *this* existence or *that* existence. *The Fate of the Animals* is about the fate, the *Schicksal*, of animality as such, of creatureliness as such, which is one of being thrown into flaming suffering, that is to say, the condition of being made to endure physicality and time, to "go through" something, "to suffer," to "pass in" and then to "pass out" of existence. But even saying these few words is, of course, already to lose the purity of what Franz Marc was trying to show us. In his letter of December 16, 1915, Marc acknowledges as much. "But below the pure region of art," he writes, "limitless nonsense is produced with language." And then, a few lines later, Marc blurts out to Maria, "One should talk much less and live only by emotion."

21. Really to look at *The Fate of the Animals* would be to have your life changed, to have everything changed.

THIS DESIRE THAT MARC BLURTS OUT to his wife, the need to "live only by emotion," is striking and bothersome. Something about it feels wrong, dangerous, unacceptable. At the same time, we know what he means. Somewhere inside we know what he means. We know that there is a way to be in contact with the depths, a way to stand before Marc's painting and possibly to shudder and to shake and be forced to turn away because of the enormity of what is contained in that painting. We know that thinking is generally the process of forming statements and reaching certain conclusions, achieving this or that goal in the process of thought.

But there is another kind of thought, another kind of mindedness that doesn't proceed in this way. It takes us around in circles and spirals. It doubles back on itself and works its way inside. It spirals down to its own foundations and then back out again. Our old friend D.H. Lawrence talks about this kind of thinking,

this kind of experience in his strange book *Apocalypse*. "While men still thought of the heart or the liver as the seat of consciousness," wrote Lawrence, "they had no idea of this on-and-on process of thought. To them a thought was a completed state of feeling-awareness, a cumulative thing, a deepening thing, in which feeling deepened into feeling in consciousness till there was a sense of fullness. A completed thought was the plumbing of a depth, like a whirlpool of emotional awareness, and at the depth of this whirlpool of emotion the resolve formed. But it was no stage in a journey. There was no logical chain to be dragged further."

Looking at *The Fate of the Animals* should be an experience something like what D.H. Lawrence describes here. It should be the process of a cumulative thing, a deepening thing. It should be like spiraling down into a sense of fullness and falling into a whirlpool of emotion. In the end, the final result of looking at and truly seeing *The Fate of the Animals* is not to form a thought at all. It is not to have an idea or to have reached a conclusion. In the end, really to see *The Fate of the Animals* would be to have one's life changed.

But this sounds silly. People say this all the time. They say, doing X or doing Y "changed my life." What they mean, actually, is that it hasn't changed their life at all. They mean the exact opposite. We say that eating at a certain restaurant changed our life, or finally switching the kind of shoes we wear changed our life. It's said with a knowing smile. It is hyperbole used to acknowledge the fact that lives are actually quite difficult to change

Really to look at *The Fate of the Animals*

in any meaningful way. In fact, you will meet very few people in your life for whom the statement such and such "changed my life" is anything but a bit of play. By using the phrase "it changed my life," we are, more often than not, forming a kind of ironic distancing wall between ourselves and the reality of life altogether. We are saying that we are not open to being penetrated and being taken down into the whirlpool. It will never happen. When we say "it changed my life," what we really mean is, "there is no possible way my life can be changed. I am closed. Nothing will happen in me or to me."

But to look and truly to see Franz Marc's painting *The Fate of the Animals* would be to have one's being transformed. The "feeling-awareness," as D.H. Lawrence calls it, the feeling-awareness of Marc's painting is a feeling-awareness that calls us out of one form of life and into another. It calls us to the revelation. To stand before that painting and to allow its form of experience to fully wash over one's person would be to accept another form of being in the world, one in which the throbbing heart of life, the great tragedy and the great beauty of life, is not held at a distance but embraced so wholly that it threatens to be overwhelming. It would be to wake up. It would be to wake up and cry like a baby in the harsh embrace of a completely new world.

That's what Franz Marc meant in saying to his wife that the future can be now, the future can be realized. He meant that the Absolute Now can be right now. He meant that that which is always present can truly be

The Fate of the Animals

present right now. He meant that the words of the sibyl, whatever those words are, are true. And if the words of the sibyl are still true, then there is a place where talking must end and the greater truth of silence must begin. Marc's painting thus cannot, in the end, be converted into words, since within that painting is also a good deal of silence, and the further you go into the painting the further the talking recedes.

22. Franz and Maria Marc dream of building a garden.

FRANZ MARC HAD BEEN EXPERIENCING a version of this "talking less" and "feeling more" eight months or so before his letter of December 16, 1915. One early spring, in April of 1915, Marc was wandering around in the gardens of whatever small town in which he was then stationed. "Everything is beginning to grow," he wrote to Maria on April 13, 1915. "It is quite exciting to stand in such a rich old garden, where spring looks at you with a million little eyes." As Franz Marc wandered around in the garden, the war was ramping up at the front lines, miles away from where he was standing in that little section of the centuries-long cultivated Europe with gardens having been sown and tended and cared for down the generations.

Marc calls old gardens like this "strangely bold." Perhaps he means that such gardens know what they are and they express what they are with forthrightness. He writes to Maria that he is "more than ever in love with the flowers and leaves." But the experience of the war, the experience of the previous months and the sights he has seen throughout the battlefields of the Great War,

the thoughts that have passed through his mind since he joined the German army and in the days and the years leading up to his joining the German army, the days and years of struggle that finally led to his breakthrough and to his truly becoming a painter in the *annus mirabilis* of the winter of 1910 into the early months of 1911—all of these experiences have impacted Franz Marc. He has fallen more than ever in love with the flowers and leaves, but he also looks at the flowers and leaves differently after all of his experiences. He writes this to Maria in quite explicit terms. "I look at them very differently now," he writes. "A feeling of pity is always present, a sense of being privy to them; we look at each other, mute and with a gesture that suggests, 'We understand each other; truth is elsewhere, the two of us have our origin in it and will one day return to it.'"

Here is another version of the intuitive thought, the flashing up of feeling, the intense inner certitude that says both "this world is necessary, this being-created is necessary" and, at the same time, "this world is a tragedy, a falling-away from any possible truth and oneness. This being-created is a painful ripping and being-thrown and being-dragged-through a process of becoming and of passing away." That is but another way of saying that all being is flaming suffering.

In his letter of April 13, 1915, Franz Marc drifts away from these reflections on his love of and pity for the flowers and leaves. He thinks of his own garden at the little house he owned with his wife Maria. He allows himself to dream about what they might do with their

A dream of building a garden

own plot of land, the garden that they might build and cultivate together. He dreams of getting old and wonders whether the process of aging will make him calmer, less agitated by the thoughts and creative impulses that tear through him. Reading this letter today, we know that Franz Marc was never to get old, that he was never to return to Maria, never to build his garden, never to cultivate his fields, never to paint the pictures that tortured his mind in the final months of his life traveling around the battlefields of the Great War on his way to his final destiny at the Battle of Verdun.

But in thinking about his garden that would never be, Franz Marc did, in a sense, have it. And he will always have it. In his letters to Maria, who is herself long dead now, the garden that the two tended only in their shared imagination exists eternally and forever. This too is an aspect of the fate of animals. Animals have this fate, the fate of being creatures who come and go and the fate of being connected to a coming and going that is absolute and eternal, that lasts in a way that their specific fleshy existence cannot last, cannot go on. This aspect of the eternal exists in Marc's painting *The Fate of the Animals* as does the aspect of suffering and the wound that is at the heart of any existing.

23. *The Fate of the Animals* has one last trick up its sleeve.

THE SUFFERING BLUE DEER AT THE center of Marc's painting is flanked to its left by other suffering animals. To its right, the deer is flanked by four more traditionally colored and traditionally rendered deer who stand next to a tree, the central tree of Marc's painting and the structural spine of the entire picture. We already discussed this tree briefly above. But now we come back to it again with an even greater ability to see it.

We said before that the tree was another of the split or shattered things of nature. But that's not quite true. Now we can see the tree as standing, somehow, partially outside the circle of existence, the circle of flaming suffering in which the other plants and animals are contained. This tree is solid, not fully split like the other trees, though at its bottom portion it also shows its rings, or we should say that Marc has managed to create a composition by which the tree can both be split and showing its rings and be fully intact at the same time. This doubly split and not split tree is, it's safe to say, a special tree. The four deer stand before the tree

in curiosity and anticipation. They are waiting for something. Standing in anticipation before the tree, they are experiencing a different kind of being than the being of flaming suffering.

Our old friend and scholar Frederick S. Levine, the author of *The Apocalyptic Vision: The Art of Franz Marc as German Expressionism*, makes an interesting observation about this special tree in *The Fate of the Animals*. Levine notes that there was once a mural at the Neues Museum in Berlin. The mural was by a German artist named Ernst Ewald. The mural was titled *The Three Norns* and was painted around 1864. Ewald is today an almost completely forgotten artist. *The Three Norns* is an almost completely forgotten work, this mostly due to the fact that the Neues Museum in Berlin was nearly destroyed during the bombing raids by Allied forces at the end of World War II. *The Three Norns* was destroyed and exists today only in photographs of the work taken before it was destroyed.

It cannot be proven, as far as I know, though I haven't done the necessary research into all of Franz Marc's papers and into all of his correspondence, but as far as I know, and as far as Levine was aware when he wrote his book, there is no way to prove conclusively that Franz Marc ever looked at this mural by Ernst Ewald. *The Three Norns* couldn't be further from the abstracted, Post-Impressionist style in which Marc painted all of his most important pictures after the *annus mirabilis* of the winter of 1910–11. Ernst Ewald, in fact, painted *The Three Norns* in a neoclassical style that,

to Franz Marc, was utterly dead and outdated as a form of painting. Still, the subject matter of Ewald's painting would have interested Marc. We know that Franz Marc was in Berlin a couple of times before his death and that he had every opportunity to visit the Neues Museum and to look at Ewald's mural. We know also that Marc was fascinated with all the themes that Ewald took up in his mural and that those themes, and even the compositional structure by which those themes were conveyed in *The Fate of the Animals*, show interesting similarities with Ewald's now-destroyed mural.

So what then is a Norn? A Norn, it turns out, is an important figure in Norse mythology. Norns are female beings. I suppose you could call them goddesses, though in some versions of Norse mythology they are described as giants. The crucial point is that the Norns are associated with fate, with *Schicksal*. There are many Norns in Norse mythology, but three Norns are the most important. These are Urðr, Verðandi, and Skuld. The Three Fates of Norse mythology can only remind us of the Three Fates (*Moirai*) of Greek mythology: Clotho, Lachesis, and Atropos. There are, of course, many similarities. But one thing specific to the Fates of Norse mythology, to the Norns, is their position in the cosmic structure. That's to say, the Norns have a place. That place is near the Well of Urðr or the Well of Fate. The Three Norns stay near to this well. Their specific job is to draw water from that well and to use the water to nourish a giant tree. The tree is known as Yggdrasil.

One last trick up its sleeve

The tree of Yggdrasil is a mythic tree. It contains the entire cosmos, or represents it, or mirrors and determines its fate. All of these ways of thinking about Yggdrasil are true at once. Or they are all false. As D.H. Lawrence says in his odd book *Apocalypse*, you cannot understand the mythic mind by setting its images down into hardened propositions. Yggdrasil is everything and, at the same time, it is that which stands outside of everything, the totality of the code by which all else gets its meaning. The tree is also the means of connection and even of travel, by way of its branches and roots, between the different realms of the cosmos. The nine worlds are held together by Yggdrasil. Yggdrasil is nature itself and also that which gives power to nature. It is the foundation of the world and the magic means of passage from one realm of the world to the other, from the terrestrial zone to the divine.

In Ewald's no-longer-existing mural at the Neues Museum in Berlin, there were four deer surrounding the tree of Yggdrasil. The four deer were shown chewing at the leaves of Yggdrasil. One meaning, at least, seems clear. The great tree is the source of nourishment for animal life. Perhaps in a deeper way we can also say that the deer reflect the way that life feeds upon itself in order to sustain itself, which leads to the inevitable thought that life is a form of death and vice versa. In Franz Marc's painting, the deer do not eat the leaves of Yggdrasil, but they do stand waiting at the side of the tree, waiting, perhaps, for a sign or for some dispensation of fate that the tree is about to give.

The Fate of the Animals

The four stags are called Dain, Dvalin, Duneyr, and Durathor. So Franz Marc has, in a sense, created a painting of Norse mythology. *The Fate of the Animals* is, thus, also a portrait of the four stags. It is a revelation of the four stags of Norse mythology chomping at the Tree of Life, the World Tree, as the drama of beings and of creation unfolds around and about them.

The great tree, the world tree Yggdrasil, also has a special relationship with Odin, who is, among other things, a father God in Norse mythology and the creator of the human race. He is also, we might say, a mad God, an insane God. This comes from the very nature of his name. The name Odin leads back to ancient roots in the Proto-Germanic language tree. Those roots show that the name Odin comes from other words that mean "mad" and also "possessed." That is to say that Odin is the prophet God, the God who, like the sibyl, stands at the very limits of language and of reason.

Odin is, moreover, the one-eyed God. He is a God who has a special and particular relationship to seeing. He is a God who wants to see everything and who wanders much. But the seeing isn't enough for him. He wants to see in a way that is more than visual. He wants to push his seeing beyond seeing into *seeing*. As the story goes, Odin travelled to the very base of the world tree Yggdrasil. He was looking for the Well of Fate, the Well of *Schicksal*. In his passion, in his obsession for seeing, Odin wanted to know what was in that well, he wanted to *see* inside the well. The Fate who guards the well, Mimir, tells Odin that he cannot see inside the well

One last trick up its sleeve

unless he yanks his actual physical eye from its socket and puts it into the well. He will sacrifice, as it were, an organ of physical seeing in order to be able to look deepest into what is *geistig*. He will sacrifice visual seeing for spiritual seeing.

That Odin is a God associated with madness and, specifically, with poetry, the poetry that is language pushed to the very limits of sayability, is perfectly understandable here. The madness of the God who sacrifices his eye in order to see. What does Odin see in the Well of Fate? There is no point in trying to express it. Odin's madness is the madness of the sybil, then. It is the madness of having access to something that is beyond the limits of what can be expressed. Odin is thus the God of the kind of seeing, the sort of spiritual looking-in, that Franz Marc attempted to access with his painting.

Franz Marc would have been very happy, like Odin, to rip one of his eyes from its socket in order to look into the Well of Fate, to gaze down into the depths of that well. One cannot imagine, by contrast, an artist like Paul Klee deciding to rip his eye out. No thanks. That would not do at all for Paul Klee, great an artist as was Paul Klee. But Klee's greatness does not come from wanting to look down into the Well of Urðr. Klee was not interested in an art that looks down into the murky depths of wells. You can't paint that, he would have said. You can't paint that which is at the root of the possibility of painting. That's like trying to paint the moment of painting before it happens. You can't paint that because

it isn't visible. I, Paul Klee said without exactly saying it, I will paint the tree. I will paint Yggdrasil. I will paint the different things that Yggdrasil can be. I will paint the various ways of Yggdrasil being Yggdrasil. But there is no point in going to the Well of Urðr. The Well of Urðr is a place beyond showing, beyond comprehension, a place where you will lose your eye, which is, after all, primarily for worldly seeing, and you will look down into a murky depth—for what? A place to lose your eye and then your mind, for the chance to catch a glimpse of madness and then finally doom? That's what Paul Klee would have said to Franz Marc and to Odin as well, had he ever had the chance.

And Franz Marc's response would have been: I run to that place, I run to the doom and the eye-sacrifice and the madness and the losing of all things in the fire of the truth that smolders at the base of the tree and that leads me down—down down down into the depths of the Well of Urðr. Did he run out, did Franz Marc run out onto the battlefield of Verdun after that very same thing, did he run out there and then finally meet the bit of steel that crashed into his skull, did he traverse the fields of death in the Great War looking, finally, for the Well of Urðr?

You can picture Franz Marc in his uniform on one of the fields of the Great War. He is in his uniform, and he sits on a horse. There is something perfect, by the way, about the fact that World War I was the last war in which the horse still had a role. The ancient beast. The taming of the ancient beast. And then also the

tanks and the machine guns right next to the horses, the ancient beasts being slaughtered by the tools of the mechanization of war, which is the true horror of the Great War. But the incongruity of it all is difficult to hold together in one's picture of the war. The wristwatches in the trenches. The precise timing. The math and the engineering and then, at the very same time, the soldiers sitting on the ancient beasts staring into the conflagration and the fire that is as ancient and absolute as has been any apocalypse, any conflagration of any time.

It should be noted that the "drasil" portion of the word "Yggdrasil" means "horse." And there is an etymology around Yggdrasil that suggests the world tree is also the hanging tree. That might be because you ride up to Yggdrasil on a horse, and then you fling a noose around a branch of the tree, and you let the horse go, just like a scene in a Western film. The horse gallops off from under the rider, and the rider is left to dangle from the tree. This too is what happens in the branches of Yggdrasil.

And in one of the old stories it is Odin who hangs from Yggdrasil. It is Odin, the God, who hangs himself from the tree of Yggdrasil. Odin is the God of madness and truth who hangs himself from the tree of the world. In *The Poetic Edda,* we have it from the mouth of the mad God himself. "I wot that I hung on the wind-tossed tree all of nights nine," Odin tells us. He hangs himself from Yggdrasil and dangles there for nine days and nine nights. "Wounded by spear" and "bespoken myself to

myself." He stabs himself, Odin does, and hangs himself from the tree. And what does he do from that tree? Why is he up there? Isn't he looking down into the Well of Urðr from up in the tree, where he is hanging, dangling between life and death, dangling in the gray space that is neither here nor there, and is thus the place from which one might actually see something? He is hanging from the Tree looking down into the Well, looking for the runes, the signs, the symbols that cannot otherwise be read. "I looked below me," Odin tells us in *The Poetic Edda*. "I looked below me—aloud I cried—caught up the runes, caught them up wailing, thence to the ground fell again."

What did those runes tell him? We can't ever know. The mad God cannot tell us, but simply hints in other riddles and codes and runes. The sibyl gives only a sign. The madness at the edge of telling can only be taken up and passed on by a further madness until finally it dwindles and fades. It passes like a mist into the language of everyday life, never transmuting into sayability, but constantly haunting what can be said with the promise and allure of what cannot.

This is how God has always and ever died, by crossing the threshold. Yggdrasil is the tree on which we witness the death of God, the mad God who sacrifices himself to himself. *Schreckross* is the terrible horse, or the terrified horse, or the horse that is terror, the horse that sits below the rider who has a noose around his neck. The tree of life is the tree of death. In the end, the story of Odin and his travels goes so deep that there aren't

One last trick up its sleeve

words for it. Or there are only words. Words at their most elemental. Names. The greatest story of Odin is probably the story in which you simply list all of his names. As Odin says in the old poems, "A single name have I never had since first among men I fared." The old Norse stories loved to do that, just to list the names of Odin. Here are just a few:

Biflidi

Fiolnir

Herran

Ialg

Nikar

Nikuz

Oski

Omi

Svidar

Svidrir

Vidrir

Maybe the names already say enough, maybe too much. You find this love of naming in so much of the ancient literature. The catalogue of ships in *The Iliad*. There are countless examples. The namings of *Genesis*. The hearers of the old works, the listeners to the ancient stories, they could sit and listen to the naming of names for hours. They felt the power just in hearing the name. Names of people, names of places, names of rivers and oceans, names of Gods. Just to say these names was an

act of worship. The greatness of Odin is the greatness of a thousand names.

There is no specific image of Odin in *The Fate of the Animals*. But some of his names are in the painting. Many of his names are to be found in the painting. The painting writhes and bumps with the tumult of Odin, with the penetrating kind of seeing that characterizes Odin and with the earth shaking and the tree destruction that comes with the coming of Odin.

24. The mad ravings of Odin meet the earth shaking of the God of the tetragrammaton.

EARTH SHAKING AND TREE destruction—where else do we hear about this? What else lingers at the edges of Franz Marc's painting? What is the force that shakes the earth and shatters the trees? This is a truth, is it not, that was already captured by a singer of the Psalms. The voice of the Lord is upon the waters, says Psalm 29. The God of glory thundereth. Here the Hebrew God and the Norse God Odin are together almost as one. They are the Gods who shake the universe, who bring the trembling, the awesome fury that brings being into being.

The voice of the Lord is powerful, sings the Psalmist, the voice of the Lord is full of majesty. And that voice, the voice of the Lord, does something specific in the Psalms. The voice of the Lord breaketh the cedars. The Lord breaketh the cedars of Lebanon. He maketh them also to skip like a calf. So now we know, in a deeper way, why Franz Marc was already painting his leaping cows even before he painted *The Fate of the Animals*. The *jouissance* of the skipping beasts

is already a hint of the strange orgiastic fury of creation, coming-to-be and destruction so closely intermingled as to be almost one. The voice that makes the calves skip is the voice of the Lord who divideth the flames of fire. The voice of the Lord shaketh the wilderness. The Lord shaketh the wilderness of Kadesh.

Being, the being of this God who is the God that is and will be, the being of this God is a being that is terrible. Not terrible as in bad. We misuse the word terrible. We call soup terrible if we don't like the way the soup tastes. This soup is terrible, we say. But soup is not terrible. Soup cannot be terrible. Soup is just soup. The dignity of soup is that it is among the order of things that cannot be terrible. It is among the order of normal things in the world, and the things in the world are not in and of themselves terrible. That which is terrible is that which is at the horizon, which can't be contained in a thought or a category, which threatens to rip asunder all that otherwise holds together.

That which is most terrible is that which is the result of the terrible forces that have opened up the space of the world so that anything may be at all. And the cosmos was ripped open in the beginning, by Marduk or Yahweh or Odin or whoever, and it was the trauma of this ripping and this sundering and this earth shaking and this convulsing of being that is the condition for the possibility of the very beings who witness the terror of that which brings beings into being.

All being is flaming suffering. It is the great unnamable act of terror that is the condition for the

possibility of there being anything at all. This is what is terrible at the very foot of existence. This is why God must be a terrible God. This is why God must rend themself asunder. Because it is in the very nature of God to tear herself apart so that she might be. To shake the earth into being and to shake the cedars into being, and to shake them such that, at the very core of their being, where the trees show their rings and the animals show their veins, is the testimony of this original wound, a wound experienced again and again in the terror of the coming into being and the passing away out of being again and again and again, the being pulled forth screaming from the wound of being and then again the disappearing back again into the murk and the nothingness from which the wound was made. A wound in the gap of being.

This is what we can see if we are ready to look upon the canvas that Franz Marc called *The Fate of the Animals*, and which Paul Klee called *The Trees Show Their Rings, The Animals Their Veins*, and on the back of which is written "all being is flaming suffering." This is the painting that was almost destroyed in the fires of the Great War but was not destroyed. This is the painting that caused, in a sense, the one who painted it, the artist who was fated to bring it into being, this is the painting that also ushered this artist, this Franz Marc, out of being in the cataclysm of the Battle of Verdun.

25. The last drawings. A surprising vision. The end

AT THE END OF MARC'S LETTER ABOUT the garden, he comes back to speaking about the war. He wants to explain to Maria something about how the war really is, what it really means. He is in despair that she will never be able truly to understand what his experience has been. "But I am telling you," he writes to his wife, "you don't know anything about the war." This is a kind of angry outburst, the cry of the person experiencing something that cannot be communicated. It is the cause, this anguish, of the typical silence of the soldier, no doubt, the cause of the mute stare from the person who has experienced battle and killing and death and horror on that level. The muteness is a refuge. It is better, this silence, than the incomprehension from those who may want to know but cannot actually be made to know what they haven't experienced.

You will see old soldiers, sometimes, sitting together in silence and in the comfort that they do not need to explain, that they know and they know that the others around them know. It is a kind of comfort that

The end

is present only among those who can share with one another the mute incomprehensibility of the fact that they hold something within that can never properly be given expression. They too are existing in the mode of suffering, the flaming suffering that is characteristic of all being but that has an acuteness in the people, the creatures, who have been brought to the very limits of experience.

After his outburst in his letter to Maria, Franz Marc reins himself in. He is aware that he has gone too far. He writes the following lines just after accusing Maria of knowing nothing about the war. "It also may be," he writes, pulling himself back from his outburst, "that I cannot or will not see it in any other way; when I see this fighting and dying, I feel as if I am looking upon nature, in which things are the same; but one does not touch its image shortsightedly, one searches far away behind it, for a far distant meaning which is the only living and possible thing in all of this."

Around the same time that Marc was writing these thoughts down in his letter to Maria, he was working on what, unbeknownst to him, would be his final thirty-two works of visual art. These are the sketchbook drawings that Franz Marc made while in the field of war. The drawings were made in a small notebook. They were made in pencil. There is no color, only the shading that Marc could achieve by means of different degrees of pressure and density of line. Franz Marc's wartime sketches have been reproduced, more or less in the exact form of his original notebook, in a handheld volume by

Sieveking Verlag called *Sketchbook from the Battlefield*. It is thus possible, now, in the early twenty-first century, to hold in one's hand a notebook that is eerily similar to the very notebook that Franz Marc once held in his hand in the early years of the twentieth century. This is the visual testimony that Franz Marc has left to us. Our hands still, in some way, touching his dirty-soldier-artist hands of more than a century ago. Our flesh still touching his flesh. A communion.

These sketches are obviously from the same mind and hand and spirit that made *The Fate of the Animals*. There are two different drawings, for instance, on which Marc has written the word "Streit" (strife). In these drawings, we see some of the same shafts of violent interruption of the picture plane that we see in *The Fate of the Animals*. At first glance, one wants to think that these sketches might be Marc's attempt to capture something of the abstracted look and feel of battle. But nothing else in the sketchbooks seems to refer even obliquely to the actual events of the war in which Franz Marc was a participant. Finally it becomes clear. Franz Marc was a participant in The Great War. But he'd stopped experiencing the war as such.

We also know that Franz Marc had, for a number of years, been interested in the project of creating a collection of "illustrations" of the Bible. I put "illustrations" in scare quotes because Marc did not want these illustrations to be literal. He imagined works that would be of the same challenging, forward-looking nature as the paintings that he and his colleagues,

The end

people like Kandinsky and Klee and Macke, had been making just before the war broke out. He was imagining a book of illustrations that would have captured the feeling and essence of various biblical passages, rather than the typical approach of illustrated Bibles in which a straightforward representational approach is taken.

We know also that Marc was frequently drawn to the opening passages of the Bible, that he was fascinated with the story of creation. We know that Marc was interested in drawing images out of words like the following, which are some of the very first words one encounters in the first chapter of Genesis: "And the earth was without form, and void; and darkness was upon the face of the deep. And the Spirit of God moved upon the face of the waters. And God said, Let there be light: and there was light." And so it would be just as easy to say that these "strife" drawings by Franz Marc are an attempt to give visual form to this opening creative tumult, this split in the void, this coming of light into the darkness, this eruption of form into the void.

And after these opening moments of creation, after the splitting of the void and the coming of the light, after the establishment of the ground and the condition for life, the creatures begin to come. The whales and fishes and flying things come. The things that emerge and writhe and skitter and squirm and multiply. The giant things and the things of the deep. And then we move to the creatures of the land, the creatures not of the wild and the deep places, but of the tame and the domestic. "And God said, Let the earth bring forth the

living creature after his kind, cattle, and creeping thing, and beast of the earth after his kind: and it was so. And God made the beast of the earth after his kind, and cattle after their kind, and every thing that creepeth upon the earth after his kind: and God saw that it was good."

It has been noted many times by many different scholars that one of the unusual things about Hebrew scripture, the writings and documents that eventually come down and are canonized as The Bible, that these writings are somewhat unusual in their time and context, in the situation of Bronze-Iron Age Mediterranean/Near Eastern civilizational structures, in that these writings are so insistent that their God, who comes in various names and guises, that this God is a God of care, a God for whom that which is created is a matter of ongoing concern and by whom creation can be called and named "good."

Make no mistake, the God of Hebrew scripture is a terrible God in exactly the way that we have already described this terror. This is the God who makes the wilderness of Kadesh shake and tremble and skip like a calf. This is the God upon whom one cannot look, because to look upon this God would be to be obliterated. Don't look at God! Cast down your gaze, your physical gaze and your mental gaze. All gazes. This God is terrible. But this God is also the God of care, the God of overwhelming unfathomable care. This God is the source, the terrible awesome source of the ripping open of the cosmos so that there can be anything at all, and this God is also an incredible tenderness at the

The end

very heart of this open wound, a tenderness in which that which comes to be is also, at its very inception, that which can be wept for, that which can be coddled and nuzzled and tended to in its flaming suffering. This terrible God of primal violence is also, in that very same act, the God of absolute gentleness.

This contradiction, if it is a contradiction, cannot be reconciled into any other greater unity. This strange contradiction at the heart of Being, the Being that is Becoming, is a strange contradiction that cannot itself be generated, cannot itself be further analyzed or explained, but that is itself the root problem by which everything else can be analyzed or explained, insofar as anything can be analyzed or explained.

Franz Marc, for his part, does not analyze or explain this root terribleness/gentleness. But he does portray it, in his own way. He had discovered, already back in his *annus mirabilis* of 1910–11, had already developed a drawing and painting style by which some glimmer of these root things could be ushered up into form, hinted at in the visual field that already gestures past the limits of the purely visual.

Franz Marc's war sketches are, in that sense, the strangest war sketches you are ever going to encounter. Completely absent are the actual images of war. There is no sign of something like what one sees, for instance, in the work of Otto Dix, the moldering corpses and the wreckage and refuge and broken world, broken people on the field of war. Absent also are the elegiac and mournful scenes that one can find in a painter like Paul

Nash, for whom the devastation of the Great War sits like a blight and blemish on the earth itself.

No, in fact, the drawings that Franz Marc made in the very last year of his life, in the midst of the raging and awful battles that would claim his own life with such brutality and violence, the work that Marc made in these, his last days on earth, were drawings of fecundity, of organic forms weaving and twisting their way amongst one another, of animal life nestled and nestling, of his beloved horses stacked in a landscape that is both strange and nourishing at the same time. He drew pictures of rocks, or rock-like structures that themselves seem to jump the chasm into the fully organic, and then also of growing things that are shot through by rays of pure existence and whose very formal unity threatens to break down and merge again into the landscape. He draws a fox, which is in every way so clearly and obviously a fox, which conveys every aspect of being a fox that we could possibly want it to convey. And at the same time, this fox is but a few triangles and squares and a couple of areas of pencil shading. The fox is real. The fox is an illusion. The fox is the chance intermingling of formal elements having come together as if in a dream. The fox sees us. We see the fox.

†

Two days before he died, on March 2, 1916, Franz Marc wrote the following words to Maria.

The end

I myself feel well—my nerves are untouched to my own amazement. . . . For days I have seen nothing but the most awful scenes that the human mind can imagine. Yesterday I was happy about getting a card from you and Lisbeth's letter to which you added something; this is such a comfort to me, to know that the two of you are together and to hear that you can exchange thoughts on human and artistic problems. Stay calm and don't worry: I will come back to you—the war will end this year. I must stop; the transport of the wounded, which will take this letter along, is leaving. Stay well and calm as I do. Be kissed and let us be together in thought all the time. Greetings to Lisbeth and the children.

<div style="text-align:right">Kisses from your
Fz.</div>

Franz Marc died at 4 p.m. on March 4.

Further Reading

Franz Marc. *Letters from the War*. Probably some of the most powerful letters ever written. They only get better as he goes along. The fact that you know he will die at the last letter only heightens the poignancy. Amazing.

D.H. Lawrence. *Apocalypse*. Lawrence's last book. He wrote it while he was dying of tuberculosis. It is a deeply strange and often mean-spirited book in just the ways that Lawrence could be both of these things. It is also brilliant.

Frederick S. Levine. *The Apocalyptic Vision: The Art of Franz Marc as German Expressionism*. A scholarly book. Deeply wrong about many things. But I stole tons of thoughts and ideas from this book without shame or regret. Plus, an angel/demon put it in my hands, which must count for something.

Paul Valéry. *Degas Manet Morisot*. This book cracks me up. It's like reading about people on another planet. In this case, the planet is French high bourgeois culture in its glorious apogee and death throes. Absurd. Beautiful.

Further reading

The Eddas. There are prose Eddas and there are poetic Eddas. Both are amazing. There are many translations and editions. This is the source material for all the Norse-Icelandic mythology that we sometimes think we know. But reading the original stuff is important. There is some raw connection to the root things of life here that is difficult to describe or explain.

Arthur Schopenhauer. *Essays and Aphorisms.* I find *The World As Will and Representation* unreadable. Schopenhauer thought he was going to out-Kant Kant in systematizing his ideas, and the result was disaster. But in the essays and aphorisms you get the gist of Schopenhauer's awful and dispiriting world view. Enjoy.

The Rig Veda. Many translations and versions to be found. These are the most ancient of the Vedic Sanskrit hymns. Utterly incomprehensible much of the time. And yet, like the Eddas, one feels that something is being expressed here that shouldn't even be allowed to be expressed. Read them aloud to a loved one.

Roberto Calasso. *Ardor.* Roberto Calasso is no longer with us. Thankfully, this book is. If you want to be convinced that Vedic culture is worth trying to understand, this is a great place to start.

The Blue Rider ["Blaue Reiter"] Almanac. This is the volume edited by Wassily Kandinsky and Franz Marc. It

Further reading

is a collection of essays, pictures, musical scores. There are reproductions of German Expressionist paintings and drawings but also of objects from around the world and from throughout human history. Anything that is *geistig*, basically. It is an astounding accomplishment. The best art book ever.

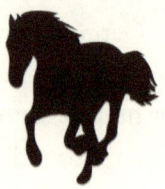

This book was set in Adobe OFL Sorts Mill Goudy, designed by Barry Schwartz and published by The League of Moveable Type, the first open-source font foundry. Based on the classic Goudy Oldstyle, this typeface retains the strong influence of calligraphy that characterized its predecessor.

This book was designed by Shannon Carter, Ian Creeger, and Gregory Wolfe. It was published in hardcover, paperback, and electronic formats by Slant Books, Seattle, Washington.

Cover art: detail of *The Fate of the Animals*, 1913. Kunstmuseum, Basel.

www.ingramcontent.com/pod-product-compliance
Lightning Source LLC
Chambersburg PA
CBHW020906180526
45163CB00007B/2638